To all the friendships
formed through the medium of
Chinese Brush Painting.

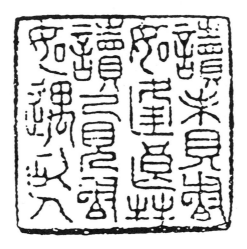

Reading a new book is like meeting
a new friend, reading an old book is
like meeting an old friend.

# The Art of
# Chinese
# Calligraphy

Jean Long

DOVER PUBLICATIONS, INC.
Mineola, New York

*Bibliographical Note*

This Dover edition, first published in 2001, is an unabridged republication of the work originally published in 1987 by Blandford Press, Poole (England).

*Library of Congress Cataloging-in-Publication Data*

Long, Jean.
    The art of Chinese calligraphy / Jean Long.
        p. cm.
    "Unabridged republication of the work originally published in 1987 by Blandford Press, Poole (England)."
    Includes bibliographical references and index.
    ISBN 0-7137-1748-3 – ISBN 0-486-41739-5 (pbk.)
        1. Calligraphy, Chinese. I. Title.

NK3634.A2 L66 2001
745.6'19951–dc21

                                                                2001028007

Manufactured in the United States of America
Dover Publications, Inc., 31 East 2nd Street, Mineola, N.Y. 11501

# Contents

# List of Photographs and Charts

The photographs in this book appear by kind permission of the following:
The Ashmolean Museum (A)
The British Museum (B)
The Museum of Oriental Art (D)
The Percival David Foundation (P)

The Ashmolean Museum, Department of Eastern Art, Oxford OX1 2PH
The British Museum, Department of Oriental Antiquities, London WC1B 3DG
The Museum of Oriental Art, University of Durham, Old Shire Hall, Durham DH1 3HP
The Percival David Foundation of Chinese Art, University of London, 53 Gordon Square, London WC1H 0PD

The following charts appear:

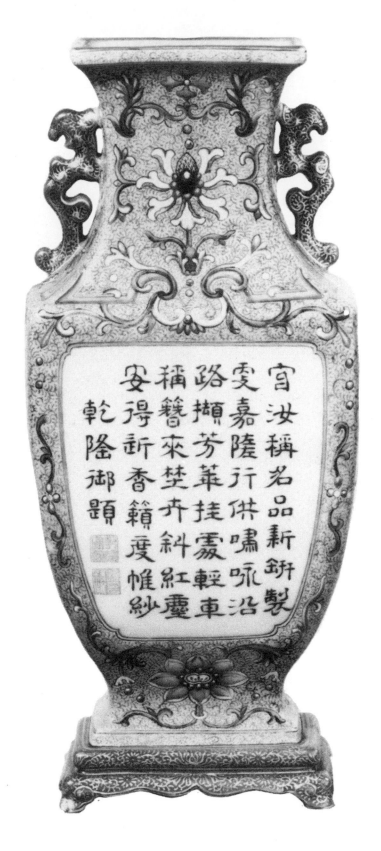

宮汝稱名品新研製
雯嘉陵行供嘴咏沿
路擷芳華挂霧輕車
稱簪來楚卉斜紅塵
安得新香籍庾帷紗
乾隆御題

*A Ch'ien Lung 'half vase' decorated in enamel colours from the period*
*AD 1736 – 1795. This Ch'ing Dynasty vase was believed to have been made by*
*T'ang Yin and is decorated with a poem composed by the Emperor in 1742.*

# Introduction

Although 'calligraphy' merely means 'words written by hand', to the Chinese it is considered an art with a history almost as long as China itself. The characters not only convey the language of thought but also, in a visual way, the artistic beauty of the thought.

This book's intention is to help people to enjoy the artistry of Chinese calligraphy without having to possess full understanding of the language itself.

The beauty and movement of the individual strokes, the patterns of their structures, the understanding of the importance of brush-strokes and the techniques necessary for readers to attempt Chinese calligraphy for themselves, are all contained within this book.

Hopefully, also, a greater understanding of the art of Chinese calligraphy will provide a clearer insight into the character of the Chinese people themselves.

# 1

# The Development of Chinese Calligraphy

The history of Chinese painting really begins with the characters and, in China, the first simple writing was said to have been invented by the Emperor Fu Hsi in approximately the 28th century BC. He used a series of line combinations to represent the basic phenomena as seen in everyday life. It was developed from two basic signs which correspond to the positive and negative elements of the universe. The Chinese call these *Yang*, which is the positive symbol, and *Yin*, which is the negative symbol.

——— Yang            —  — Yin

## Trigrams

From these two symbols developed what is now called 'the Eight Trigrams': eight different combinations of the symbols. Triplets of horizontal lines, either continuous or broken, represent 'Heaven', 'Earth', 'Wind', 'Thunder', 'Water', 'Fire', 'Mountain' and 'River'. It is interesting to note that 'River' merited a symbol of its own and was not within the 'Water' Trigram.

*The eight trigrams.*

Heaven    Earth    Water    Fire    River    Mountain    Wind    Thunder

Similarly 'Mountain' could not be allowed to be a mere part of the 'Earth' trigram, but had to have its own symbolic representation, no doubt because of the important place that rivers and mountains have in Chinese conceptual thought.

Under these headings, other meanings were evolved for objects which shared characteristics of hardness, strength and masculinity which the straight *Yang* line symbol represents. For instance ☰ not only represents Heaven, but also 'Emperor', 'Father' and 'Gold', 'Head' and 'Horse'. The divided line of the *Yin* symbol equates to 'Softness', 'Weakness' and 'Femininity', so that ☷ can also denote 'Mother', 'Cloth', 'Breast' and 'Cow'.

This list gives only a few of the meanings of the trigrams, including their representation of symbolic animals.

☰ Heaven, Creativity, Energy, Conflict, Jade, Ice, Head, Father, Gold, Horse

☴ Wind, Wood, Gentle, Cockerel

☵ Water, Toil, Moon, Ear, Pig

☶ Mountain, Birds, Seed, Hand, Dog

☷ Earth, Yielding, Mother, Cloth, Breast, Cow

☳ Thunder, Green Bamboo, Foot, Dragon

☲ Fire, Light, Consciousness, Sun, Eye, Cock-pheasant

☱ River, Joyful, Month, Sheep

Collecting the eight symbols into one diagram surrounding the *Yin/Yang* symbol in the centre produced the *Pa-Kua* which was the origin of all Chinese characters.

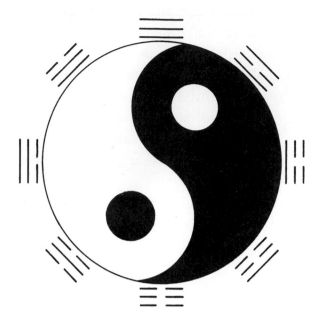

Arranged in a circle, the symbol of Heaven, they correspond to compass directions, the times of the day and the seasons of the year. Temples and houses were built to face South – the peak of *Yang* vitality, with East and dawn on the right and the depth of *Yin* at their back.

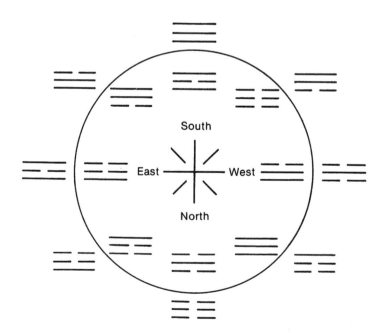

The outer circle represents the living world arrangement, the inner circle, the later world arrangement.

## Pictograms

Recorded history shows that, in the period 2697 – 2596 BC, the time of the Yellow Emperor, the Imperial Recorder, T'sang Chieh devised a recording system by engraving natural objects on sticks, from which evolved both picture-writing and art.

Fish

Boat

A 9th-century historian recorded that Ts'ang Chieh, who had four eyes, looked up at the heavens and was inspired to copy bird-footprints and tortoiseshell markings to help him make the forms

*Green jade bell with Pa-Kua design of the Ch'ien Lung period (AD 1736 – 1795).*

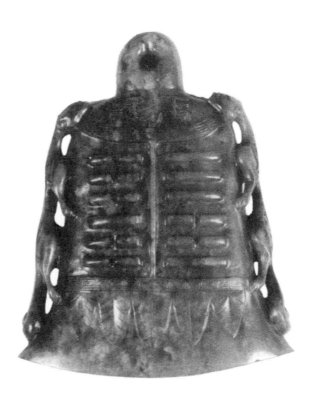

of written characters. The spirits were said to have cried out at night to him, encouraging him in his creativity.

Some artefacts have been found which show imprints of these early characters.

From the Hsia Dynasty (2205 – 1786 BC) there are Tripod engravings, from the Shang Dynasty (1786 – 1135 BC) there are shell and bone remains with characters engraved and from the Chou Dynasty (1135 – 247 BC) there are bronzes. Different versions of various animals, the elephant, the deer and the tiger as well as fish and boats, are all represented on archaeological remains.

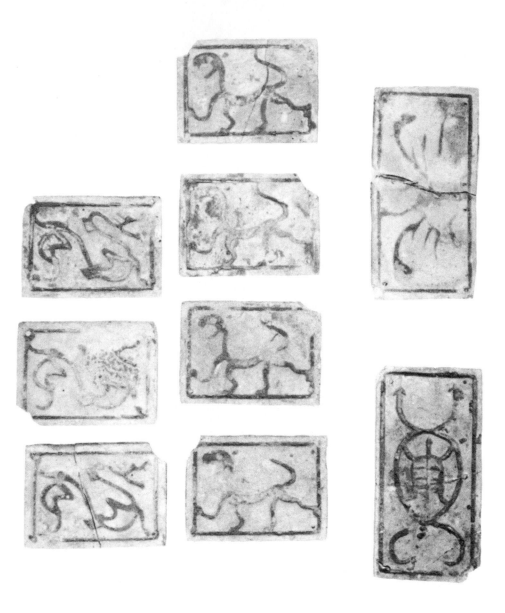

*Glass plaques with ancient animal and calligraphic decorations. Each measures approximately 4 × 5 centimetres (1 ½ × 2 inches).*

## Shell and Bone

The writing on shell and bone remains was made in the first instance with a brush and then carved into the hard surface with a knife. The average size of each character was approximately 0.5 centimetres (¼ inch), so the brush must have been quite small. Conjecture suggests that it was probably a mere centimetre or so (about ½ inch) long and no more than 0.5 centimetres (¼ inch) in diameter. As the lines of the characters were so rigid and stiff, the brush must have been made of some stiff kind of hair, such as wolf, deer or sable.

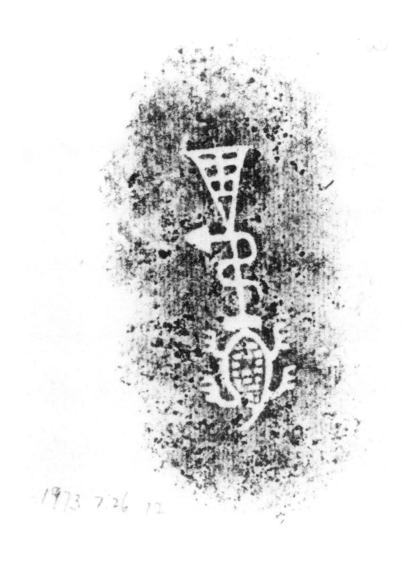

*Rubbing from a Shang ritual vessel showing a calligraphic tortoise.*

The Shell and Bone characters are formed in vertical columns, reading from right to left and from top to bottom. Commonsense suggests that this development resulted from the fact that early writing was done on slats of wood and bamboo, which could be tied together more easily in a vertical format to enable reading to continue consecutively. 'Lacing' of books is mentioned as early as the 6th century BC. The vertical format helped to create an emphasis on vertically-structured characters which became part of the Chinese tradition of writing.

Because the writing was so tiny, it would seem that a seated position would have been the most comfortable one for these early calligraphers. Although it is not usual to rest the wrist when creating decorative characters, it may well have been necessary to do so in this instance. Modern calligraphers still use Shell and Bone writing because it was, in essence, the first demonstration of writing as an art form, although based on predominantly vertical lines.

*This ink rubbing shows the Great Seal Inscription which was carved on one of the famous Chou Dynasty Stone Drums in about the 10th century BC. It has been reproduced from a copy made in the Northern Sung period (AD 960 – 1127).*

## Bell and Pot Style

Characters cast on bronze vessels during the periods of Shang and Chou – from the 14th to the 3rd centuries BC, were all incised into the metal objects in a 'V' shape. This rather more advanced style of writing is sometimes called Metal style or Chin Wen (*Chin*

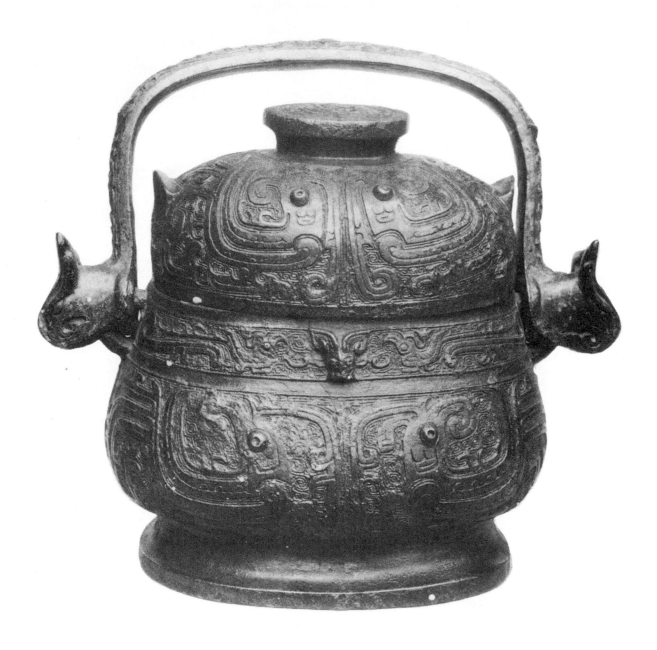

*This is a Chou Dynasty ritual vessel, 20 centimetres (8 inches) high and 18 centimetres (7 inches) wide, showing the animal shapes so popular during this period.*

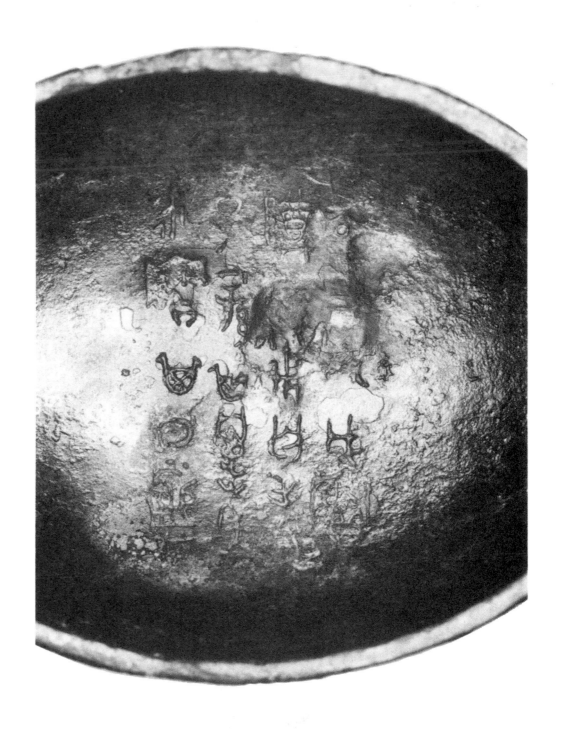

*A ritual vessel from the 10th century BC inscribed with ancient characters.*

is metal, *Wen* is character or word). The characters used contained combinations of dots and lines as well as curved shapes but, perhaps even more importantly, were put together in beautifully arranged compositions. The bronze vessels were cast from clay or wax models on which the characters had been carved.

While the Shell and Bone style of calligraphy was used for the mundane requirements of daily life – for correspondence, for oracle-recording and for fortune-telling, the Metal style was much more decorative. This was a very important step forward in the development of Chinese calligraphy as writing was now becoming an art form in itself. Pictorial designs were put on these metal vessels side by side with the calligraphic symbols. The characters were no longer all the same size, nor fixed into a set framework. Shapes could be discerned, such as triangular, rectangular and circular, while the characteristic use of positive and negative space made the compositional element of the calligraphy much more interesting. The picture signs accompanying the text were very much a part of the family ethos as the astrological faith of this society predestined their occupations – a fishing net showed that the whole family for generations were fishermen; a weapon showed that they were all in military service.

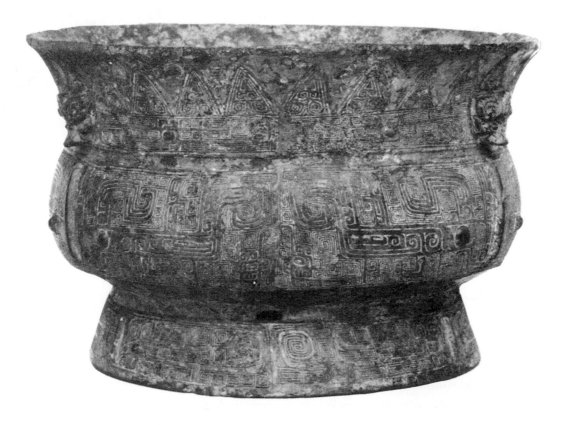

*A Shang ritual vessel with early calligraphic decoration, 14 centimetres (5½ inches) high by 23 centimetres (9 inches) wide.*

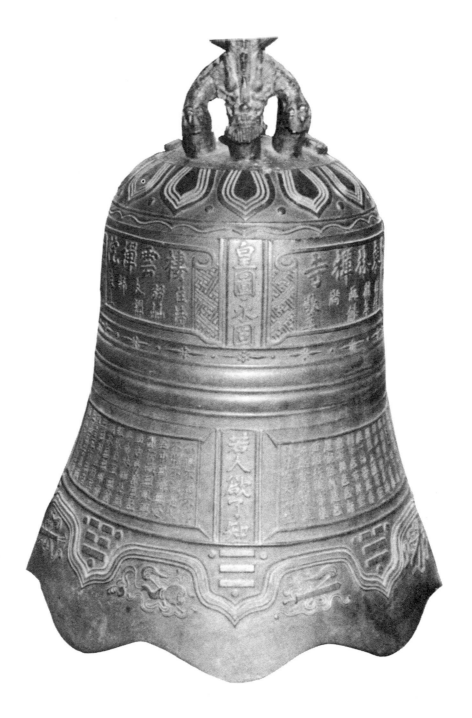

Much of the history of the ancient Chinese has been learnt from
the inscriptions on the bronze vessels for not only did they
indicate the status of families in society, but many of the vessels
were used to record military campaigns, treaties, ceremonial
occasions and other important events in government and family
life. Because of its durability, many legal matters were cast on
bronze, not, as may have been expected, in a rigid writing style,
but with the freedom of spirit that makes the calligraphy a work of
art.

As the Chou period extended over so many years, different styles of calligraphy developed, some of these being confined to geographical areas of this vast country. The Southern style was decorative, with lines like steel wires, so that the composition seemed to be an expression of perpetual motion. The other notable style was called 'Bird style' because the features of birds were to be found in each character. Both these styles were to be very influential on the later artistic development of Chinese calligraphy.

## Stone-drum Style

Stone-drum style, so-called because it was discovered on ten stones, formed in the shape of drums, whose heights ranged from 45 to 90 centimetres (18 to 36 inches), has been attributed to the Chou Dynasty of about the 8th century BC. It is a classical style, well balanced and even, with emphasis on the vertical structure of the characters, but showing a decided difference in the use of the brush. Instead of writing lines only with the centre point of the brush, a different pressure has been applied. The side of the brush came into use, pressing more deeply onto the writing surface and so the lines became wider and rounded at the ends. The elements of each character can now be seen structurally as 'bone' shapes. Instead of hard, angular edges to the brush strokes forming the basis of the carving, the lines became soft, fluid and round. Contemporary artists are still influenced by this imposing style.

## Chu Chien

Side by side with the carvings on metal and stone, the bamboo strips continued to be used as a basis for writing. *Chu Chien* means 'Writing on bamboo strips or tablets' – a medium used from the 18th century BC until the 4th century AD when paper became a popular medium. Some pieces found in a tomb dating from the Warring States period (circa 400 BC), contain from two to twenty-one words on tablets averaging 22 centimetres (8½ inches) long by 1.2 centimetres (½ inch) wide and 0.1 centimetres (³/₁₀₀ inch) thick.

The brushwork on these examples shows improvement on that

demonstrated on the stone drums. The brush had become a tool to be more widely manipulated and more skilfully used. Variable pressure of the brush showed in each stroke, where the beginning was heavy and rounded and the end, light and pointed. The brush was no longer restricted to the making of even lines, but could be moved in high or low positions, with fast or slow movements. Because the calligraphy had become more vigorous and flowing, the speed of the writing also increased and this movement was allowed to show in the overall composition.

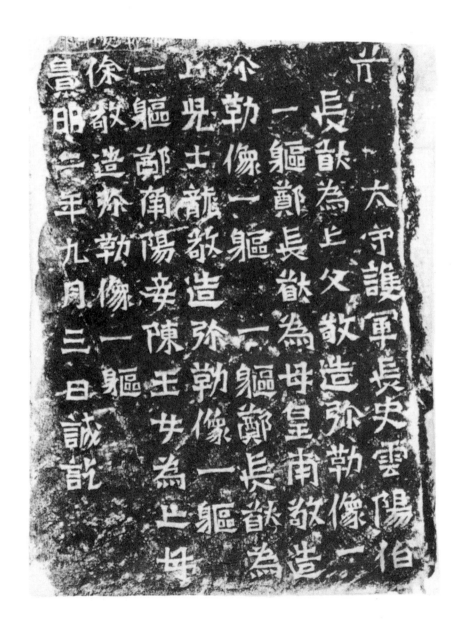

*Columns of calligraphy from a rubbing (AD 501).*

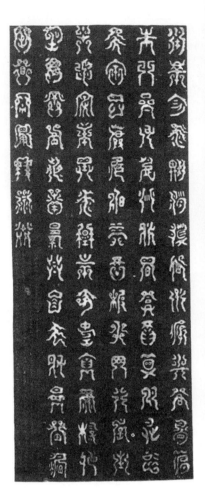

*A rubbing of the record of the legendary Emperor Yu of the Hsia Dynasty on regulating the waters. From a stone engraving of AD 1666 (Ch'ing Dynasty).*

## Writing on Silk

The oldest piece of silk discovered appears to have come from the 4th century BC. Measuring 47 × 38.7 centimetres (18 ½ × 15 ¼ inches), there are about 750 characters written on it. The style is clear and regular and exists side by side with decorative painting.

## Seal Style

Development through this 2000-year period shows calligraphy as having passed through the straight-line period, where the writing was solemn and dignified, to an era when brushwork, expressiveness and design began to feature more significantly.

After the period known as 'the Warring States', the Ch'in Dynasty emerged (246 – 207 BC), unifying the empire through organised military force. During this time, one of the most notorious of the Chinese Emperors, Shih-Huang-Ti, wanting to eliminate the philosophical ideas of the past, in 213 BC ordered that all books in existence should be burnt. Scholars were also burnt alive in this purge. The only books left were those of a practical or useful nature – on agriculture, medicine and divination. However, he did also have a very positive influence on Chinese writing in that he standardised the written language, so that, even today, in spite of all the different spoken dialects in China, everyone can communicate through the common written script. The disciplined, highly artificial writing that evolved was not very popular but has survived as a style for seal engraving which is still in use today.

24

### Li Style

The formality of the Seal style made it a difficult medium for everyday use, so the Li style developed which was quicker and easier to produce. For the first time, all the brush was used in the formation of characters. From the tip to the heel, a wide range of pressure was brought into play, making possible the formation of wedge shapes and triangular and hooked strokes. The turning of the brush gives a continuous flow to the line so that the brushwork is lively and harmonious.

While the Li style was in the process of development during the first part of the Han Dynasty, there were considerable changes taking place in Chinese society. An ordered democratisation was being established, using well-educated, carefully-selected officials known as 'mandarins'. Everyone was given access to schools and provided with the opportunity to advance from rank to rank by taking examinations. Education, talent and knowledge were the requirements for advancement, rather than origins or family connections. Part of the examination system involved written work based on Confucian writings, which was assessed on the beauty of the calligraphy as well as the number of remembered quotations. Good writing became an essential requisite and was one of the six arts taught at the Confucian School. Many fine calligraphers emerged during the Han Dynasty, establishing brushwork and calligraphy as true art forms. Since Li is beautiful to look at, yet still easy to write, it has become the most influential style in Chinese calligraphy.

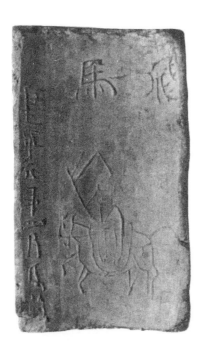

*This is an architectural brick decorated with a figure on horseback and an impressed eight-character inscription. The writing is in Li-shu official script. 2nd century AD (Han dynasty).*

## Chang Tsao Style

The Han period also saw the development of another influential style of Chinese calligraphy – Chang Tsao. *Chang* means 'Writing' such as essays, articles etc and *Tsao* means 'Grass'. The term 'Grass' in brushwork implies fast and spontaneous use of the brush. The brush strokes are natural, strong and artistically pleasing. It was well used not only by ordinary people, but also as an official script. Many modern calligraphers have modelled their work on this style.

*A copy of a funerary tablet. This is an 8th-century rubbii (Ch'in Dynasty).*

26

Much of the development of calligraphy during this period took place as a result of the invention of paper in AD 105. No longer did the artist have to work on the narrow and restricting format of the bamboo strip, which took so much time and work to prepare. Large characters could now be written and new movements with the brush were possible. The flexibility of the brush, together with the potentials of the newly invented paper surface resulted in a proliferation of innovative calligraphers.

### Kai Style

The Han Dynasty was followed by the Three Kingdoms, where experimentation in brushwork resulted in the shape of each character developing into that of a square. A new artistic dimension was reached where angular, sharp-edged brush-strokes combined with curved lines to give movement to calligraphy within the confines of the square word format. This style was called Kai.

China's most famous calligrapher General Wang (AD 307 – 365) emerged during this period. He represented the pinnacle of the art of Chinese calligraphy, firstly because his brushwork was superb, but also because he varied the composition of each character in so many ways while still maintaining design and balance within the whole. His most famous work is the 'Canons of Longevity'. The style he used, that of Lesser Kai, is still used today for the writing of official documents, reports and examinations. Handling a difficult skill with ease is implicit in the art of calligraphic writing. Nervousness and over-carefulness can make the results very wooden, but Wang's excellence lay in his effortless, well-spaced strokes flowing onto the paper without hesitation so that each stroke, each word was in balance with the whole piece of work. General Wang mastered all three of the current styles – Kai, Hsing and Tsao.

### Tsao or Grass Style

A simplified form of writing, Tsao shows the true skill of Chinese brushwork. It exemplifies the description that 'Chinese calligraphy is nothing but dancing on paper'. Its essence is its

continuity. A whole column of characters are written without the brush leaving the paper. This calls for complete mastery of brush technique, but produces a flowing spiral which is imbued with dancing rhythms and even produces an emotional response in the viewer. Sometimes difficult to read as it has a tendency to become abbreviated, Tsao has had considerable influence on the artistic emphasis of Chinese calligraphy.

The first National Collection of Calligraphy was made by the Emperor Yang of the Sui Dynasty (AD 586 – 617), who built a huge palace which he divided into 'The Two Mysterious Terraces', the eastern side of which was called 'Mysterious Calligraphy'. Unfortunately, most of the collection was lost when, journeying to Yangchou, the boat sank.

Perhaps the difficulties of coping with Chinese calligraphy are exemplified by one of the 7th-century giants in the field – the 'mad' calligrapher, Chang Hsu. Claiming that the performance of a female sword dancer had influenced his brush strokes, he produced work in which the rise and fall of the calligraphy could indeed be compared to the movements of dancing. His work often dispensed with all the previously established rules. His 'Stomach Ache Note' cares nothing for the structure of the characters, but distorts and exaggerates to such a degree that it approaches an almost abstract art form. Chang usually performed best after a drinking bout and then even he himself could not read the words he had written. Sometimes one word would be up to five times bigger than the other words in the composition. During his lifetime he was regarded as a master in writing which came to be known as the Mad Grass style.

## Fei-Pai Style

The famous calligrapher Chao Meng-Fu (AD 1254 – 1322), who was also a painter, once wrote 'Painting and writing are fundamentally the same; to paint a rock is to write in the Fei-Pai style; to paint a tree is to write in the Chu style'. The Chu style has already been mentioned as the earliest form of seal writing and consisted of strong, regular strokes, while the term Fei-Pai is of later origin and literally means 'Flying taffeta', taking its name from the curls and sweeps made in the air by the sashes of dancing girls. To write in Fei-Pai style implies that the brush seems to be following the graceful curves of the flowing silk.

28

## Development of Calligraphic Styles

The brush has been the important influence in the development of both painting and calligraphy. Early writing used the brush merely as a tool, but later work involved brushwork as an art form in itself. Writing grew from the need to express ideas, from a pictorial form as civilisation matured, through definitive styles to its emergence as the Art of Calligraphy.

*This is a 17th-century model of a ridge tile, used as a wrist-rest. The inscription says:*

*'Let lute and book rest on it, even fish and bird are friends'.*

*Made in blue and red, it is 9 centimetres (3½ inches) long.*

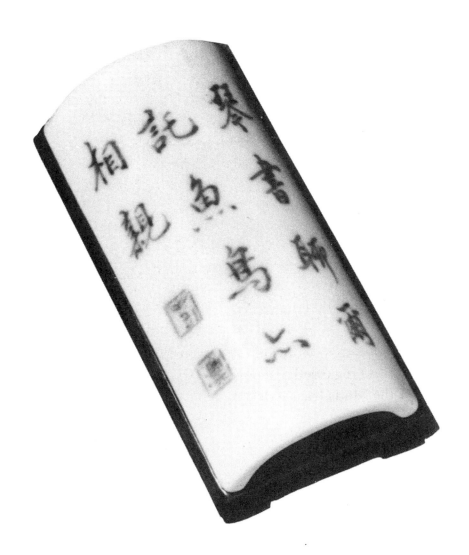

The following Table of Calligraphic Styles shows how the various styles overlapped during their period of development, some being popular for only short periods of time, while others have maintained their influence into the 20th century.

*Table of Calligraphic Styles*

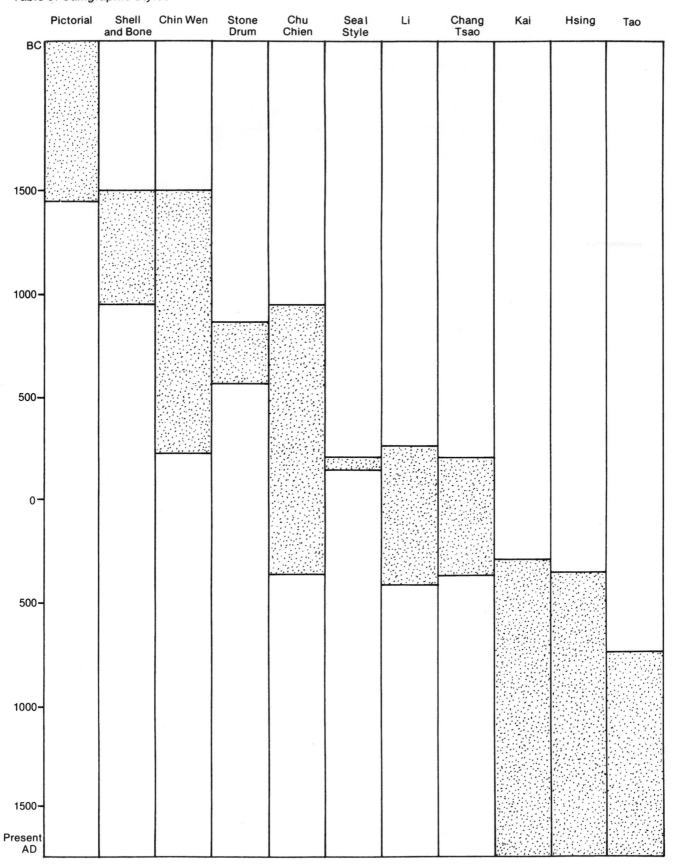

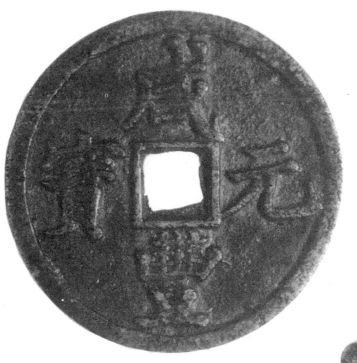

*A Manchu cash coin of AD 1851. Hsien feng (Ch'ing Dynasty). Tallies were issued to army commanders as a form of credential, with one half being kept at headquarters and sent with important messages as proof of genuineness. Usually carrying an inscription, giving the name, rank and appointment of the owner, the tally was often in the shape of a tiger.*

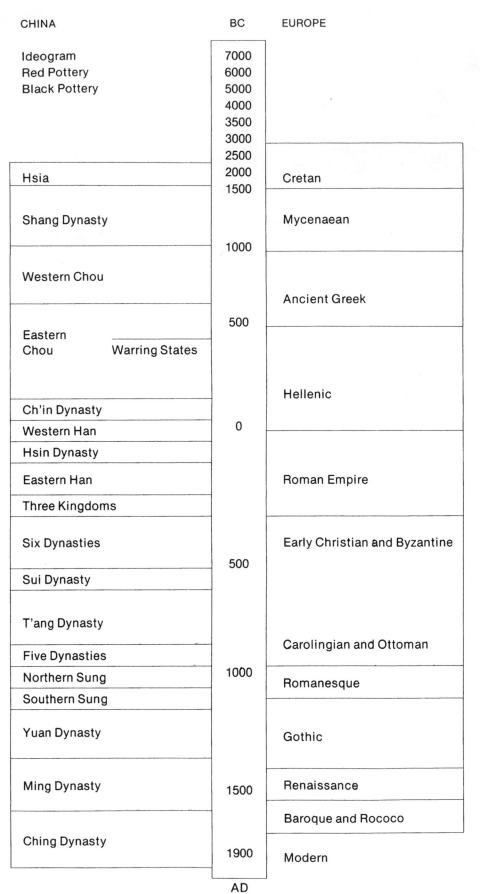

| CHINA | BC | EUROPE |
|---|---|---|
| Ideogram | 7000 | |
| Red Pottery | 6000 | |
| Black Pottery | 5000 | |
| | 4000 | |
| | 3500 | |
| | 3000 | |
| | 2500 | |
| Hsia | 2000 | Cretan |
| | 1500 | |
| Shang Dynasty | | Mycenaean |
| | 1000 | |
| Western Chou | | Ancient Greek |
| Eastern Chou — Warring States | 500 | |
| | | Hellenic |
| Ch'in Dynasty | | |
| Western Han | 0 | |
| Hsin Dynasty | | |
| Eastern Han | | Roman Empire |
| Three Kingdoms | | |
| Six Dynasties | | Early Christian and Byzantine |
| Sui Dynasty | 500 | |
| T'ang Dynasty | | |
| Five Dynasties | | Carolingian and Ottoman |
| Northern Sung | 1000 | Romanesque |
| Southern Sung | | |
| Yuan Dynasty | | Gothic |
| Ming Dynasty | 1500 | Renaissance |
| | | Baroque and Rococo |
| Ching Dynasty | 1900 | Modern |
| | AD | |

*Comparative Table of European and Chinese Art*

These early dates are still the subject of scholarly argument and are therefore only approximate.

# ② Chinese Calligraphy as an Art Form

Since Chinese calligraphy is a visual art which developed from the utilitarian act of writing, what aspects of this form of painting should be considered or reacted to when experiencing its artistic merits?

First and foremost, the overall painting conveys an impression of its form. The shape and structure as a totality has the power to convey sentiments and ideas, while the individual elements of the whole reinforce and amplify personal reactions.

Early Chinese culture believed that the universe moved in a circle and that the shape of the earth was a square with the sides running in the four compass directions. This emphasis on the 'round' and the 'square' continued into rules of conduct and development of character. One should be 'round and smooth' in dealing with people, but 'straight and square' in one's own conduct. Indeed, the word 'circle' has implications other than 'round' in that it signifies 'completeness and fulfilment'. These elements are echoed in the form of artistic calligraphy.

The established forms are directly related to nature – to the perceptions based on personal observations. Brush strokes parallel natural forms and are named accordingly. Different 'dots' are called 'nail-heads', 'rat's tail' or 'axe-cut' not for their physical resemblance to the real things, but for the feelings generated by the nature of the objects. The vital essence which each living element contains, its *Ch'i*, is encapsulated within its calligraphic form.

The construction of each Chinese character is accepted as standard but the form can, and does, take on a different appearance and expression depending upon the skill of the calligrapher and the mood to be conveyed.

Although all calligraphic characters consist of dots and lines, the dots are not mere round blobs, but have tails which follow the flow of the movement of the writing. They vary a great deal in thickness and require considerable technique to ensure the

fluidity of movement so essential to the *Ch'i* of the character. The illustration below shows some examples of different Chinese dots and lines. Both dots and lines should possess *Li*, a word denoting 'vigorous strength'. In particular the quality of 'line' in calligraphy needs to reflect 'bone' structure.

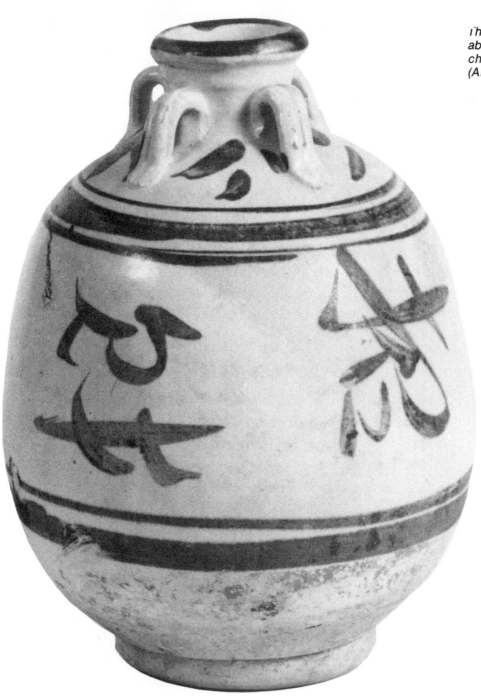

*The bottle is decorated with abstract calligraphy. It is Tz'u-chou ware of the Sung Dynasty (AD 960 – 1279).*

Each 'line' should be an entity in itself. It should be solid and strong, conveying an impression of living bone structure, with muscle, flesh and blood, so that it has the tension of vital movement. This tension is created by painting a one-stroke line without hesitation and while maintaining even pressure and speed.

The artist's mood and frame of mind at the time of painting a piece of calligraphy is reflected in the finished work. Coherence is achieved by completing the writing in one continuous session,

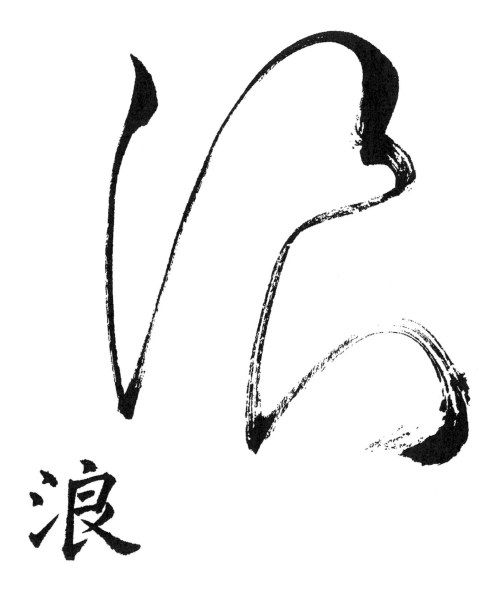

*This character is a cursive form of 'Long' written by Mei Ling, one of the author's students, in Durham 1985.*

otherwise the *Ch'i* is lost. Each piece of writing which is done as a continuous column can be described as having 'one-breath' feeling. Even working at different times of the day can affect the *Ch'i*, as usually early-morning calligraphy will give a feeling of freshness, while that of the afternoon may seem full of energy. Later-evening writing can often appear slightly tired in its essence.

One of the most important artistic concepts contained within all types of Chinese painting is the feeling of space. Faculties of perception, of seeing and of feeling all contribute to the psychological consciousness of space. The unique expression of Chinese calligraphy develops its own space consciousness. Chinese ink painting is always, to some extent, an abstract concept generated by the rhythmic effects of line which calligraphically create their own space.

Western writing is a combination of many letters forming words, but Chinese characters are composed of different shapes of lines and dots, with each grouping occupying a unit of paper space. Each unit is an arrangement where all parts balance and echo each other, forming an almost architectural structure. Suggestions of depth are created by these symbolic lines, so perspective is not needed in Chinese painting, as it is the viewer who creates the space within his or her own imagination.

The composition of the columns of writing provides movement appropriate to the subject matter. Chang Hsu's Mad Grass style of writing was influenced by, and then represented, the sword dance. In the same period, Wu Tao-Tze was influenced by a military dance and echoed this feeling in his calligraphic writing. Music, dance and calligraphy create and express movement in space and the *Ch'i* helps to provide an atmosphere in which this spatial movement can be expressed.

A piece of calligraphy possesses all the elements of a painting – form, space, texture, movement, line and composition. It can also be regarded as the abstract expression of any combination of these elements. Lei Chien-Fu once wrote a piece of calligraphy which represented the ebb and flow of the waves in an incoming tide. His inspiration, though made up of words, was in reality an abstract painting. Following the flow of the brush stroke, the twists and turns of the brush, can enable the viewer to enjoy and experience the feelings which the artist has endeavoured to express.

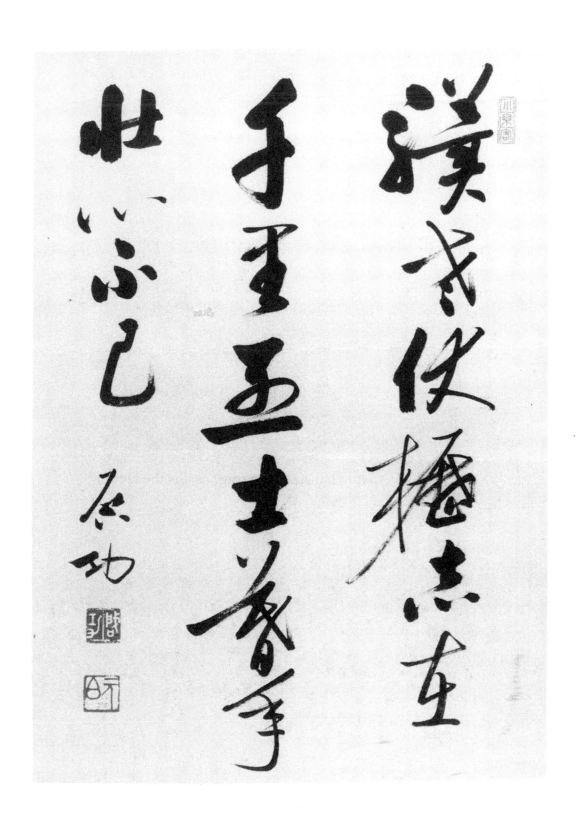

*A calligraphic hanging scroll by Qi Gong, measuring 62.5 centimetres (24½ inches) wide by 43 centimetres (17 inches) long.*

  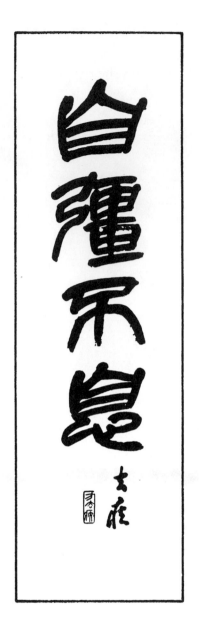

Studying old history
helps in the learning
of new ideas.

Keep self-control
always.

*These bookmarks are intended to encourage reading.*

Calligraphy has an economy of line and a simplicity of spatial form which allows individual imaginations to expand and enjoy the artist's written thoughts.

In the same way that a Chinese artist may be a specialist in landscape or horse-painting, adept at fishes or flowers, so the calligrapher will await the inspiration of the mind to produce from

within himself a creation, made up of characters alone, which is visually artistic and, on another level, capable of appreciation through the meaning of the language itself. It is a visual dimension of thought.

Calligraphic paintings, both horizontal and vertical, abound everywhere in China. Not only in palaces, where originals are admired and treasured, but in the humblest home where spartan walls are enlivened with well-read copies of sayings from the ancient philosophers, Mencius, Lao-Tsu and Confucius, to the modern dicta of Chairman Mao.

*Interior of the Palace of Heavenly Purity.*

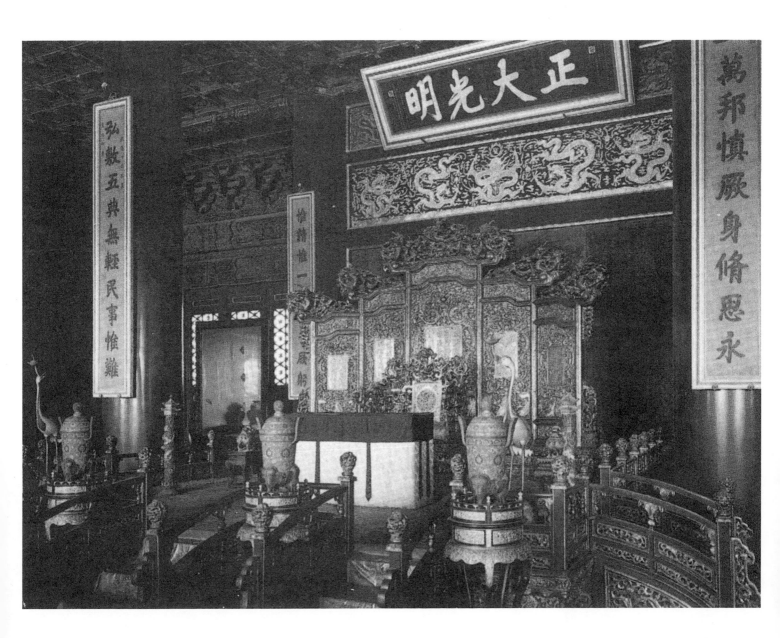

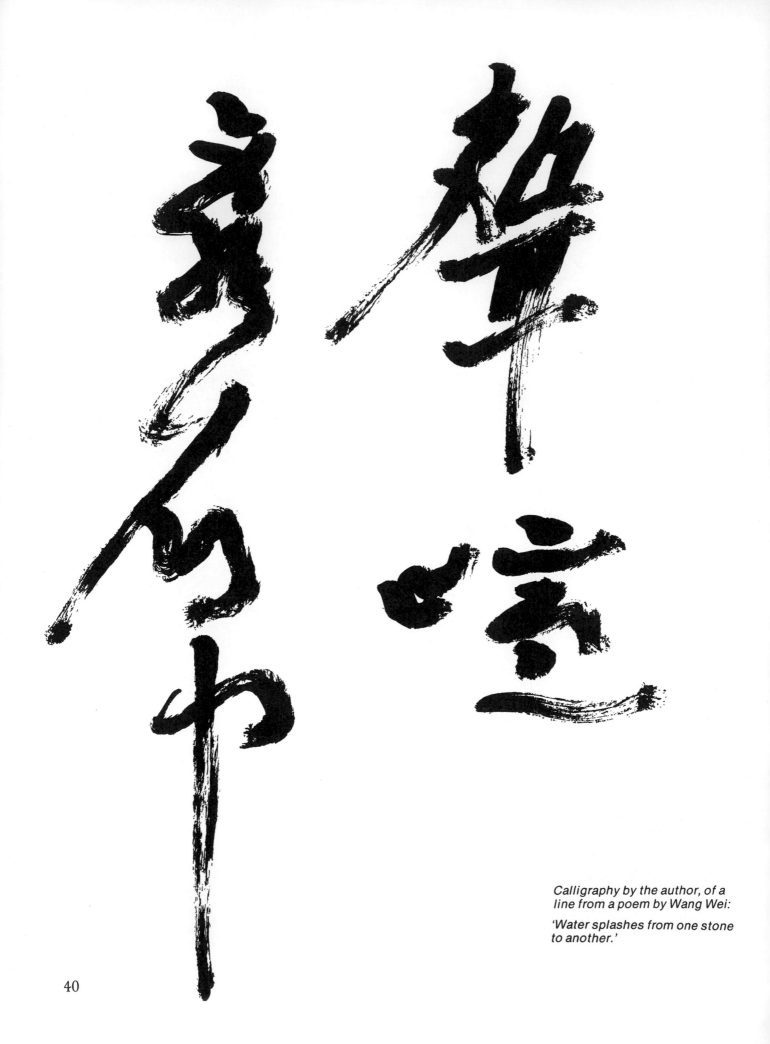

*Calligraphy by the author, of a line from a poem by Wang Wei:*

*'Water splashes from one stone to another.'*

During the Sung Dynasty (AD 960 – 1279) Chinese artists began to combine painting, poetry and calligraphy to form what they called the 'Three Perfections' of artistic expression.

Although it was quite usual for an artist to combine all three talents, it was also customary for calligraphy painters to write out the poems of famous poets of the past.

One of the most famous Chinese poets was Wang Wei (AD 699 – 760) who lived in the T'ang Dynasty. Su Shih, an 11th century poet-painter said of Wang Wei's work:

In every poem there is a painting;
In every painting there is a poem.

*Calligraphy painted by Professor Joseph Lo at the Third Conference of the Association of Chinese Brush Painters in 1986.*

晚年惟好靜
萬事不關心

Calligraphy by the author:

'In my old age I like to be quiet and carefree.'

*Lines from the Tao Te Ching, the calligraphy by Kevin Yau, one of the author's students. Durham 1985.*

## The Chinese Couplet

Probably the first couplet was written by a Taoist poet of the
T'ang Dynasty, but by the 10th century, couplets written on
scrolls were being used as wall decoration by the educated élite.
The 'Spring' couplet, written specially for the New Year, became
popular in the 14th century when the first Ming Emperor ordered
every household, rich or poor, to have such a decoration on their
main door on New Year's day.

Composing couplets became a widely cultivated social
accomplishment by the 17th century and was used to test people's
education and native wit by setting a line to be matched. Until
recently, Chinese children were trained in the writing of couplets
by exercises: first single-word opposites, then two-character
pairings, and so on until they graduated to five-character and
seven-character couplets or more. Even today, on funeral scrolls,
in temples and shrines, at scenic spots, inside restaurants,
publicly and privately, newly composed couplets abound.

A couplet, as its name implies, is made up of two parts, called
the Head and Tail, with the same number of characters in each
part, a contrast being provided, either word for word, or phrase
for phrase. In painting a couplet, the calligrapher had the choice
of either combining the two parts on one scroll or writing each
line on a separate scroll and then hanging them symmetrically.

The 17th-century wrist-rest on page 29 is decorated with a ten-
character couplet.

## Mounting Chinese Paintings

When a large calligraphic painting is completed, it has to be
mounted on to backing for presentation in its finished form as a
scroll.

The mounting process involves placing the painting right side
downwards on to a smooth clean surface, then pasting it all over
so that the paper is totally soaked, with a natural paste similar to
cold-water wallpaper paste. Creases and irregularities in the
paper can be removed by patient and careful 'easing' of the
creases from the centre to the edge of the paper. The backing
material can then be lowered onto the pasted paper and the two
surfaces firmly brush-pressed together.

A five character couplet
painted by the author:

'Living near the water
    one know the nature of
    fishes;
Living in the mountains
    one understands the
    sounds of birds.'

近
水
知
魚
性

居
山
語
鳥
嚴

In China, mounting is a special craft which takes years of patient practice to achieve. Expensive embossed silk is often used as backing for the painting paper, with narrow edges gently laid by hand on to the finished mounted picture.

Because this mounting process involves completely soaking the printed paper, it is vital that the ink does not run when wet. It is for this reason that it is so important to use ink made from an ink stick if the paper will need to be wet-mounted. Nowadays there are tubes of black ink, Chinese bottle ink, fountain brushes and other ready-to-use writing implements, but these calligraphic media may well be unsuitable for use on the absorbent paper.

The long thin scroll format, vertical or horizontal, is well known as being an essential element of Chinese painting. Less appreciated by Westerners is the space and size given to the painting by its surrounding mount, which can often be as large as the painting itself, in particular on the hanging scroll. A piece of calligraphy, mounted in the traditional manner, achieves a quiet grandeur of calm simplicity well suited to stand the test of time.

## Chinese Decorated Letter-paper

As beautiful calligraphy has always been highly regarded in China, old letters written by well-known calligraphers are greatly prized and avidly collected and have, in fact, been regarded as art treasures since the Han Dynasty (206 – 23 BC).

In the 5th century, Liu Hsieh, discussing the essentials of a well-composed letter, suggested that it should 'unburden its problems, share its hopes and dreams', and be written with elegance and mastery of the writing brush.

Sending letters in China was a slow and often expensive process and at certain times it was even illegal, thus accounting for letters from the Hsin Dynasty (AD 303 – 379) carrying the phrase 'on penalty of death'.

For some letters, exactly eight lines were required. Husbands rarely wrote to their wives. The language used for letters was flowery and elaborate. With so many conventions for the writer to observe, it is clear that each letter merited both thought and expertise.

To provide a setting for such letters, the paper used could not

be plain white, which was used only for letters of condolence or if the writer was in mourning, but was ornate and decorated with flowers, figures or landscapes. Woodblock artists designed special papers for their own use as well as to order. Some of the papers were faintly painted, others were coloured, but all served to provide a background for the elegant calligraphy of the letter-writer, whose painting space was regulated to fall between the sizes of 12.7 × 20.3 centimetres (5 × 8 inches) and 20.3 × 27.9 centimetres (8 × 11 inches).

The modern equivalent of Chinese decorated letter-paper has only a few bamboo stems or a small landscape instead of the all-over painting so beloved of the ancients.

# ③
# Language as a Way to the Understanding of Chinese Thought

From the period of the Chou Dynasty, the calligraphic symbols have been divided into six categories, of which the three main categories are: pictograms, ideograms and phonograms.

Pictograms *(Hsiang Hsing)* have developed from conventional pictures of objects, such as *Mu* ( 木 ) 'Tree' or *Shan* ( 山 ) 'Hill'.

Ideograms *(Hui I)* are characters which are made up of combined images, such as *Ming* ( 明 ) 'Sun-moon' = 'Bright' or *Hsien* ( 仙 ) 'Man-hill' = 'Hermit'.

Phonograms *(Hsieh Sheng)* are made up of a pictogram which gives the meaning and a phonetic which gives the sound.

The phonetic *Chu* ( 主 ) 'Firm' gives its sound as follows: with *Shou*, 'Hand', it makes *Chu* ( 拄 ) 'To lean upon'; with ( 亻 ) 'Man', it forms *Chu* ( 住 ) 'To dwell'.

These written characters reveal the thought processes of the Chinese mind as they show, in developing combinations, how word-meanings came into existence.

Key characters giving a clue to meaning are called 'radicals', while the characters which indicate sound are called 'phonetics', although some combined characters can have several meanings.

The character for 'A Person', 'A Man' is 人 . When a person stretches out his arms he becomes 'Big' 大 . However big a person becomes, the sky is always above him, so 'Sky' and 'Heaven' are 天 . This same character also means 'Day' (when light dawns in the sky).

Since both singular and plural are represented by the same character, then 'Everybody' is 人 and 'Everyday' is 天 . The 'Sun' 日 and the 'Moon' 月 , which also means 'Month' (as it begins at the new moon), combine their two lights shining on man to produce the character for 'Brilliant', 'Bright', 'Enlightened' 明 .

(Note the characters are side by side.)

The pronunciation of this character is 'ming' which is the name given to the dynasty of AD 1368 – 1644 which was noted for its

great artistic achievements and, in particular, the brilliance of its porcelain and paintings.

Much of the philosophy of the ancient Chinese shows itself through the combination of characters as they develop. The 3000-year-old *Book of Changes* says: 'When a thing reaches its limit, it turns around'. Interpreted as 'Following the darkest night, must come the dawn', the character for 'Tomorrow' is constructed from 'A bright day': 明天 . (Note, one character is now underneath.)

One of the most important elements of life is 'Water'. To the Chinese philosopher, Lao-Tsu (6th century BC), it became the essence of many concepts. He said:

Who can make the muddy water clear?
Let it be still and it will clear itself.

Even more important, perhaps, was his description:

Nothing is so gentle, so adaptable as water
Yet it can wear away that which is hardest and strongest.

The character for 'Water' is 水 *(Shuǐ)* and, developed from the earliest drawing 水 , 'Mountain' is 山 *(Shān)*. Together these two characters symbolise the essence of nature's wonderful 'Landscape' 山水 *(Shānshuǐ)*.

Man's first writing was achieved by holding a stick |
in his hand 彐
and scratching a line —
on a bone, shell, bamboo or wood tablet — . Approximately 4000 years ago this character for 'Pen' developed 聿 and, in later times, came to mean 'Brush', as this was also an instrument for the formation of characters.

The development continued as writing developed:
'To speak' 曰 is a 'Word' — within a 'Mouth' 口 so that a 'Pen', 'Speaking' becomes a 'Book' 書 or 'Writings'.

Similar to the character 'To speak' is a 'Subject' 田 which, together with 'Brush' and the remains of a 'Picture frame' — , becomes the character for 'A painting' 畫 .

*Sixty-four ways of writing the character* Shou *meaning 'Long life'.*

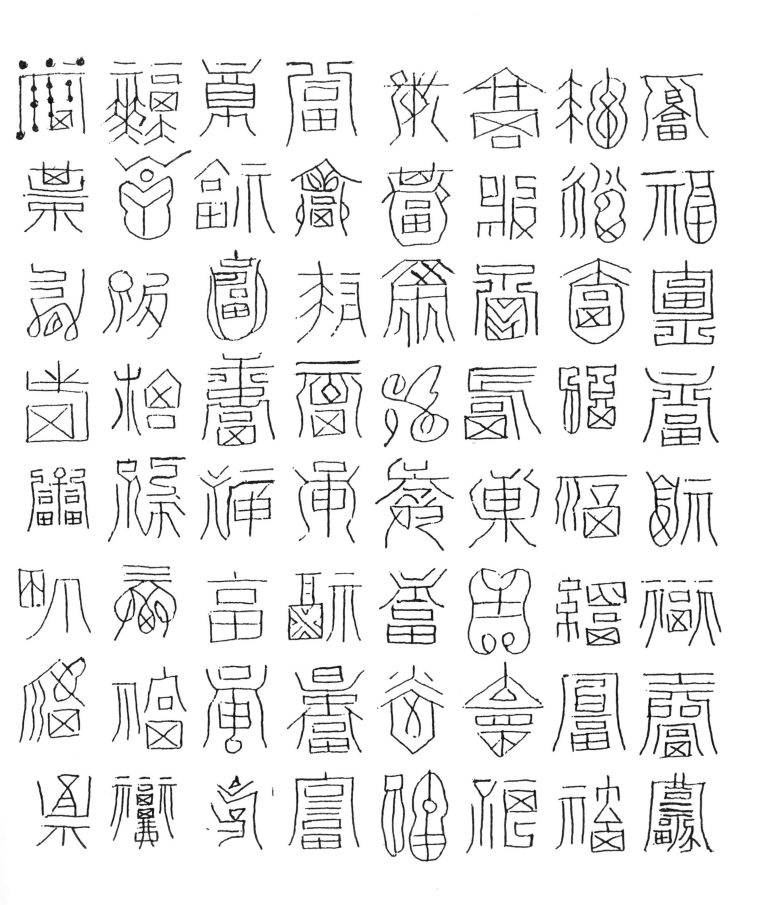

*Sixty-four ways of writing the character Fu meaning 'Happiness'.*

51

In the 3rd century BC, seals were used to stamp impressions on clay. This was originally shown as *p*. Eventually these seals were inked onto paper and later developed as printing. Combining to form this character were modified versions of the old script for 'A Hand' ⊦ written ⌁ to make 'To Print', 'To Stamp', 'A Seal ⌁p .

Finally, 'Peace and contentment to all':

# 4

# The Calligraphic Seal

Originally, in about the 5th century BC, seals were sculptured in clay and used as a security measure to guard important articles against interference. By the 2nd century BC, more seals were being carved, usually in metal. The seals of the highest provincial officials were oblong and made of silver, magistrates used square silver seals and the lower officials used seals made of wood. Since official seals denoted the power of authority, they came to be considered as potent amulets for the cure of diseases.

Following the development of official seals, individuals had personal seals made showing their own names. Eventually nearly everyone had an individual seal of their own, carved on wood, stone, jade, horn or ivory, usually using ancient characters, which served as their personal signature.

The artist, recognising the decorative impact of such seals, decided to make use of them, so that they became, and still are, an important part of the composition of a painting or piece of calligraphy.

Seal carving is an art form in itself. The calligraphy can be bold or intricate and the design, traditional or innovative. Using a knife point on a hard surface requires both strength and control. Some surfaces are very difficult to carve, others are easier if the base material is soft.

*The author's own seals.*

Although it is not essential for all seals to be calligraphic in design, this is the usual form, since their main purpose has always been to serve as a personal identification or signature.

Perhaps the most famous Chinese painter of modern times, Chi Pai Shih (AD 1863 – 1956) now known as Qi Baishi, was originally a carpenter whose speciality was carving decorative designs on the furniture which he built. When his paintings achieved fame he began carving and re-carving his stones, grinding them smooth in between, until the stones were totally useless, before he was satisfied with the standard of his work. Eventually his seals were regarded and appreciated as works of art in themselves, particularly since he took considerable pains to choose stones which were individually beautiful. He usually had some 300 stone seals in his studio, which he called 'The Three-hundred-seals Studio'.

*This is a copy of one of Ch'i Pai Shih's seals which says 'Rich man with 3 hundred stone seals'.*

Certain provinces of China contain stones which, because of their colour, grain and texture, are especially good for carving. The texture must be neither too hard nor too soft.

Soapstone, although often used because it is not expensive, wears out quickly – the lines carved on it do not hold their rigidity. Granite and jade are so hard that they are extremely difficult to carve and consequently chip easily.

Special names are given to sought-after stones, such as *T'ien-huang* – a milky yellow, almost translucent stone when flawless, and *chi'hsueh* (chicken blood) which is named for the bright red areas contained within it.

The God of Longevity seal illustrated has been carved out of soapstone to decorate the author's seal, which is contained within the base. The decorated stone box has eleven seals of various sizes with carved butterflies and bees showing on their tops. They can be purchased like this without anything carved into their bases and they await the painter's choice.

*Soapstone seals.*

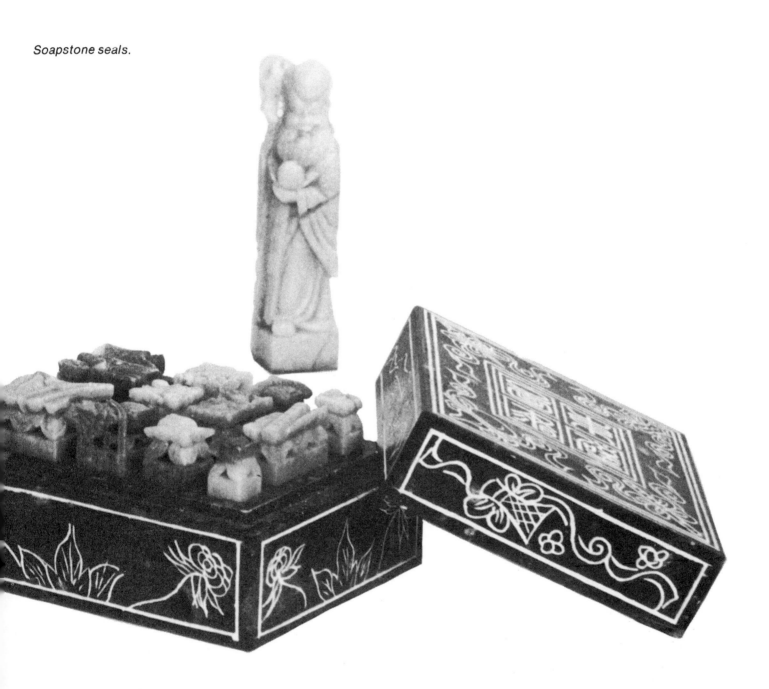

There are two different kinds of seal-carving. One is executed in positive lines (red characters or *Chu Wen*). This is called 'relief' carving because the stone is carved away to leave the characters standing out on the stone. *Pai Wen*, or negative lines, produce white characters against a red background. This is called 'intaglio' because the characters are carved 'out' of the stone.

Far away sailing boat
setting sun and wind
on the river

Osmanthus scents the air
in autumn, particularly
when the moon is bright.

Swallows fly where the
willow twigs drop down.

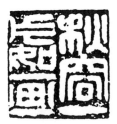

The autumn scenery is
like a painting.

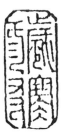

Three friends in Winter
(pine, bamboo and plum)

A kind-hearted person
enjoys long life.

Protection for the
long life.

Spring stays in the Plum
Pavilion, summer vanishes
at the Lotus Pond. This
is self-enjoyment.

Hastily and carelessly.

Satisfaction means
happiness.

Standing before the
moon.

*The illustrations on pages 6, 56 and 57 are all from a set of Metal seals in the
P. Cherrett Collection. Known as 'Mother and Child', the set contains twenty-
five different seals, two of them being the engraver's name.*

Stones can be carved in any size or shape, there are no fixed rules in the seal art. However, when the seal is to be placed on a painting or piece of calligraphy, then it must be an appropriate size for the intended composition. It is partly for this reason that artists need to have many seals and also why, if it is at all possible, they prefer to carve their own.

Every Chinese artist acquires a number of special names or *Hao*; some are self-selected, others are nicknames given by friends. The painter will probably have a seal for each of these names and one for the special name of the studio work-place. Chao Meng-fu christened his studio the 'Gull-Wave Pavilion' and Wu Chen named his 'The Plum Blossom Retreat".

In addition, from late Ming (16th and 17th centuries AD) onwards, painters and owners also added seals which contained quotations, philosophical sentiments, or comments on when and how a painting was commissioned.

A painter will collect a number of seals for his own use. When an artist dies he may have decided to give away the more valuable ones to his favourite students, or perhaps they would be kept by relatives as items to be treasured. Occasionally the Chinese artist may leave instructions for the seals to be destroyed as so many of them are individually personal.

The first seals appeared on a painting during the T'ang Emperor's reign in AD 627 – 650 and grew to popularity in the 12th century. From the 16th century onwards, collectors and inscription writers added their seals to those of the painter himself. These additional seals showed appreciation, ownership and connoisseurship but, when the number of seals added reached thirty and included large seals which used up the empty space so essential to the painting, or in some cases actually impinged upon the painting itself, then the general result was to spoil the composition. However, seals have helped to authenticate paintings and chart the history of those who owned the picture, telling when and where it was exhibited, as well as who had admired it during these periods.

The seal is an integral part of a Chinese work of art. It provides balance to the composition and adds additional interest by virtue of its own intrinsic merit. It should blend harmoniously with the lines of the calligraphy or painting, enriching the content of the work. Sometimes artists partly covered their signatures with their seals.

*The author's Christmas and New Year card 1985.*

恭賀聖誕
新年快樂

珍朗

Although in size the seal is comparatively small, it can provide infinite pleasure. Its lines are as beautiful as a calligraphic painting; the design is similar to that of a miniature composition, with every tiny space carefully thought out and every dot crucial to the harmonious concept of the design.

When a seal is placed in a lower empty space to balance a painting, it is called a 'balancing foot' seal – its purpose being to complete the composition.

Most modern Chinese artists use three seals for a picture: two for the artist's name – they are placed after or below his ordinary signature, and one more elaborate seal containing a line of poetry or a philosophical idea. This latter seal would occupy a separate place on the painting as befits its literary and aesthetic value.

If seals are put inappropriately on to a painting, blocking the picture's space, they can look intrusive or aggressive and ruin the composition. A monochrome painting is especially vulnerable to the impact of seal placings, as the vermilion red of the seal attracts the eye, contrasting as it does with the quietness of the shades of black. This touch of bright red, so beloved by the Chinese as a celebratory colour, can be compared to 'adding the eye to a Dragon' – an operation which immediately brings life to the subject.

The bright red used for impressing seals is cinnabar paste, made up of mercuric oxide, ground silk and oils. This combination is poisonous and should only be used to make the seal impression. Black or blue seals are added to paintings during periods of mourning.

'I create a tradition
of my own'
Ch'i Pai Shih

'Unworldly moron'
Ch'i Pai Shih

*Authentic chops.*

Cinnabar paste used for the seal is usually contained in a decorated ceramic pot, housed in a brocade box. These items were art objects in their own right and formed an additional decorative element to the items on a scholar's or painter's desk.

*Cinnabar paste in containers.*

Seals are so much a part of Chinese art, in all its forms, that it will come as no surprise to find that they appear as the final touch to complete the design on ceramics, on embroideries and on papercuts. This Tientsin papercut design for a candlestick is a copy of the general shape of those used on the family altar. They were made to be pasted on pillars at times of celebration. The top of the papercut shows the four characters for 'peace on earth' on the candle and then, working downwards towards the base, an ingot for prosperity, the endless knot for long life, a lotus for purity, the two *Hsi* characters for double happiness and a coin design.

*Tientsin papercut.*

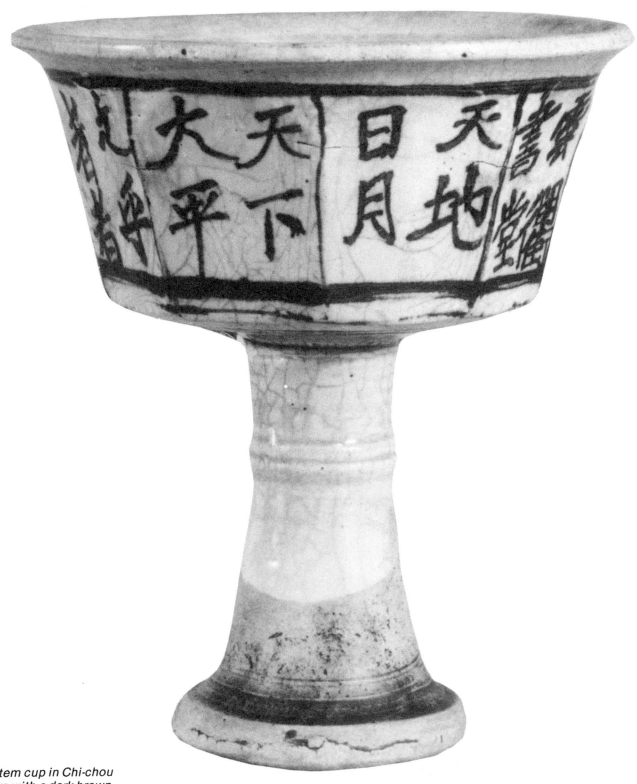

*A stem cup in Chi-chou ware with a dark brown inscription. This 10 centimetre (4 inch) high cup was made in the Yuan Dynasty.*

This Chinese blue-and-white vase has as its main motif a tree which has metamorphosed into a calligraphic symbol.

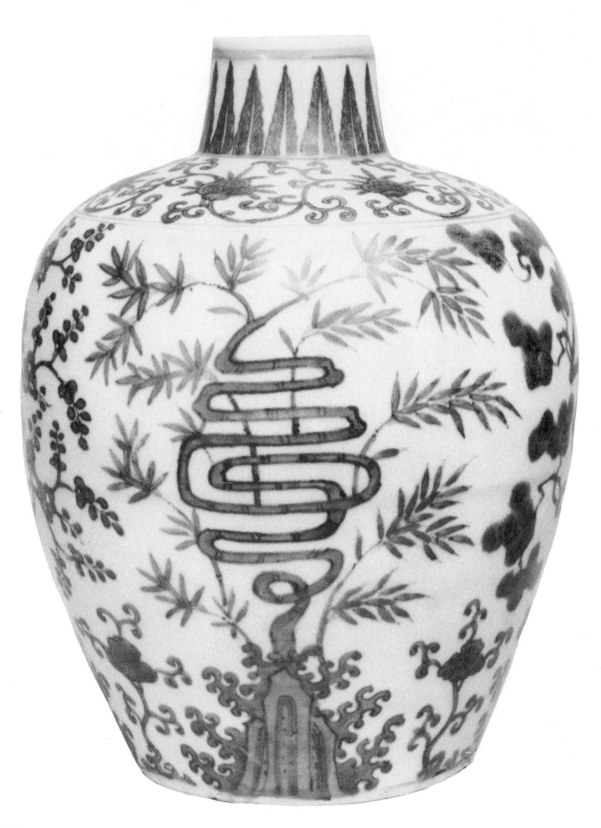

# 5
# Chinese Porcelain and Ceramics

Chinese porcelain usually has marks on the base of the object, either impressed or painted in underglaze colours. Although the marks are most often done in blue, other colours such as red, black or gold can also be found.

These marks are, in the main, one or more of five kinds. There are dates, hall marks, signatures, comments or descriptions and symbols. Ordinary characters or ancient seal script may be used for the calligraphic marks.

Dates, which may also be found in this form on paintings, can be given in one of two systems. Firstly, using the 60-year Chinese cycle which began in the year 2637 BC, or, more commonly, using the names given by the Emperors to the periods of their reigns. Called the *Nien-hao*, the Emperor designated his reign-name on the New Year following the death of his predecessor.

Usually composed of six characters, written in two columns, the first characters give the name of the dynasty, followed by the Emperor's reign-name and ending with the words 'period-made'. The *Nien-hao* marks are sometimes abbreviated to four characters and omit the name of the dynasty.

4 化 大 1
5 年 明 2
6 製 成 3

Translating the mark above reveals:

|  |  |  |  |
|---|---|---|---|
| *Hua* (hua) | 4 | 1 | *Ta* (great) (of the) |
| *Nien* (period) | 5 | 2 | *Ming* (Ming) |
| *Chih* (made) | 6 | 3 | *Ch'eng* (in the Ch'eng) |

Below are some examples of date-marks on Chinese porcelain and other works of art, although, unfortunately, due to the Chinese preoccupation with, and veneration for, their past, it was often the case that earlier seals would be put on work of a much later date, thereby making it very difficult to assess accurately the dated genuineness of an article.

Ch'ien Lung
(1736 – 1795)

Ch'ien Lung
(1736 – 1795)

T'ung Chih
(1862 – 1873)

Sometimes porcelain is not dated, but is impressed with a hallmark, which can best be compared with the modern potter's mark. This '*hall*mark' almost literally referred to a potter's or painter's studio or a dealer's shop, although the reference could either indicate where the work of art was produced or the place for which it was intended.

*T'ang* which means 'A Hall', *Chai* meaning 'A Studio' or *Fang* 'A Retreat' are all commonly used for these hallmarks.

*Yu t'ang chia ch'i* 'Beautiful vessel for the jade hall.' Late Ming/early Ch'ing Dynasties.

*Tan ning chai chih* 'Made in the pavilion of peace and tranquillity' AD 1736 – 95.

Studio marks are more commonly employed than signatures, as it is quite usual for several people to have participated in the production of a Chinese ceramic, as indeed also happens with paintings, each person contributing their own particular expertise so that the finished artwork is as near perfection as possible.

*A cylindrical jar, decorated with 2 confronted four-clawed dragons with a flaming pearl between them. In a rectangular panel between the tails of the beast is an inscription:*

*'The disciple Huang Tao-chun of She-hsien in the Hui-chou district of Chiang-nan, is happy to set before the altar of the Hall of the Three Religions in Chi-ning Chou this incense vessel, as a perpetual offering and an entreaty for the swift restoration of peace and happiness to (the people of) the rivers and lakes. Made to order in the first autumn month of the i-wei year of the Shun-chih period of the Great Ch'ing.'*

*(The three religions are Confucianism, Buddhism and Taoism.) The jar (diameter 19.7 centimetres/7⁴/₅ inches) was made in 1655 in the Shun-chih period of Ch'ing.*

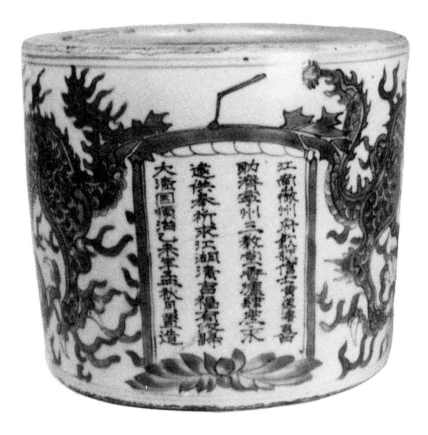

Calligraphy can also be a very important decorative element on ceramics of all kinds. The blue-and-white porcelains of the Ming Dynasty are perhaps the most well-known Chinese ceramics in the Western world and many of them demonstrate the visual excitement of calligraphic decoration. In some cases the writing is formalised; on other pieces the script is free and flowing. Vases, cups, bowls, jars, basins and dishes, utilitarian in purpose but

decoratively beautiful in their simplicity of line, clearly demonstrate the craftsmanship of the underglaze blue and copper red of Ming wares. Paraphernalia associated with calligraphic brushwork – porcelain brush-handles, water-droppers, ink-palettes, wrist-rests, writing-boxes, brush-rests, seals and water-pots were also produced during the 15th to 17th centuries. Two examples of calligraphy on porcelain are shown below, together with translations of the writing.

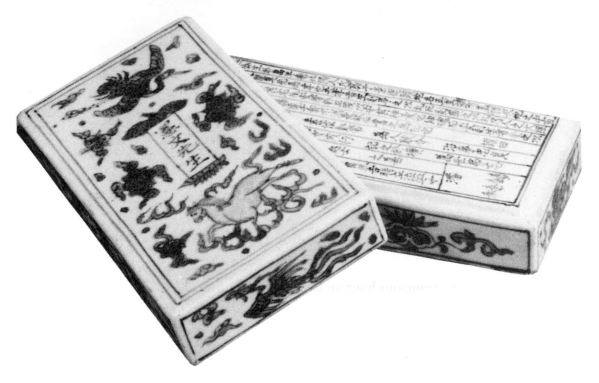

*Tomb tablet with cover. Ming, Chia-ching period AD 1555. Length 18 centimetres (7 1/10 inches), width 9.7 centimetres (3 ¾ inches).*

The tomb tablet illustrated is in the form of a rectangular box, decorated round the straight sides with fungus scrolls, birds, flowers and fruits, insects, a phoenix and a lion. On the top is a small rectangular panel in which is the dead man's descriptive name; round this are clouds, a crane and a fiery horse. On the upper face of the lower half of the box is written the epitaph and eulogy.

On the cover the man's name is given as Hsien-wen Hsien-sheng. The epitaph and eulogy in translation read:

He was born in the district of Wan-nien and was a man of Pei-yu; he is buried at Ching-te Chen in the cemetery of Wu-li as in the heart of the

universe. Nothing comes before filial piety. Those who have filial piety serve the living according to the proper ceremonies, and the dead they bury in accordance with the rites; this is man's greatest duty. Now by divination we have found this place and the omens are auspicious. The coffin is interred in the mound in order to bring tranquillity to the spirit. When the spirit is at peace, the living inherit happiness, wealth and honours for as long as a thousand years and ten thousand generations. The reason why we have written this is to keep the record. Our eulogy says:

Oh! Alas! Your goodness and virtue,
You lived simply, in peace and prosperity,
As a man you were resolute and straightforward,
In all you did you were loyal and good,
You fostered respect for precedence between old and young
And your sons and daughters have flourished.

We record this in the tomb for ten thousand generations that you may not be forgotten.
In the tomb of the retired scholar, the late P'an Shao-t'ang, of the Ming Dynasty, known as Hsien-wen, his mourning sons set up this tablet at an auspicious hour on this good day, 24th day, of the 10th month, in the winter of the 34th, i-mao year of the Chia-ching period (7 November 1555).
P'an Tai, P'an ch'un, P'an Ch'in, P'an Feng.

This translation is taken from Margaret Medley's *Illustrated Catalogue* and clearly indicates that, in this particular case, the body had been re-interred. It is quite interesting to speculate on the reasons for this, but perhaps the most likely is that it was forced on the family because of the failure of *Feng-shui* – the failure of the airs and the winds to bring benefits and blessings to the dead man's posterity. It quite clearly indicates the importance of geomancy as experts would have had to be called in to locate a new and more suitable site for the body by calculating the denary and duodenary cycles, the positions of the four Celestial Animals, the twenty-eight Constellations, the good and bad aspects of *Yin* and *Yang* and the Eight Trigrams. Then when the new site was discovered, an auspicious day for the ceremony would have to be worked out. Not surprising then that the family gave such a full explanation of their father's death on his tomb tablet.

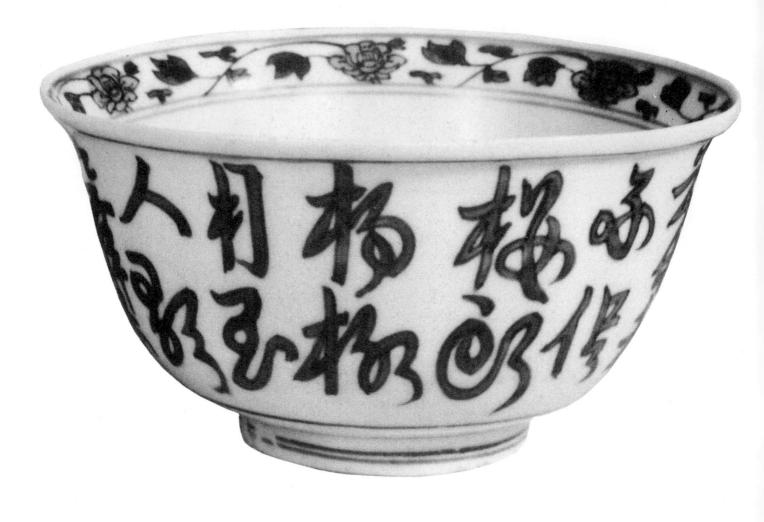

This blue-and-white Ming Dynasty bowl carries the mark of the period of Lung-ch'ing (AD 1567 – 72). The slightly flared rim is decorated with a peony scroll while the inscription is a poem reading:

'Not only does the moon shine through the willows before the storeyed
    house,
But the pretty girls continue to dance and sing.
The nightjar ceases not to sing until the fourth watch of the night;
Take heed lest the silk worms have not leaves enough.'

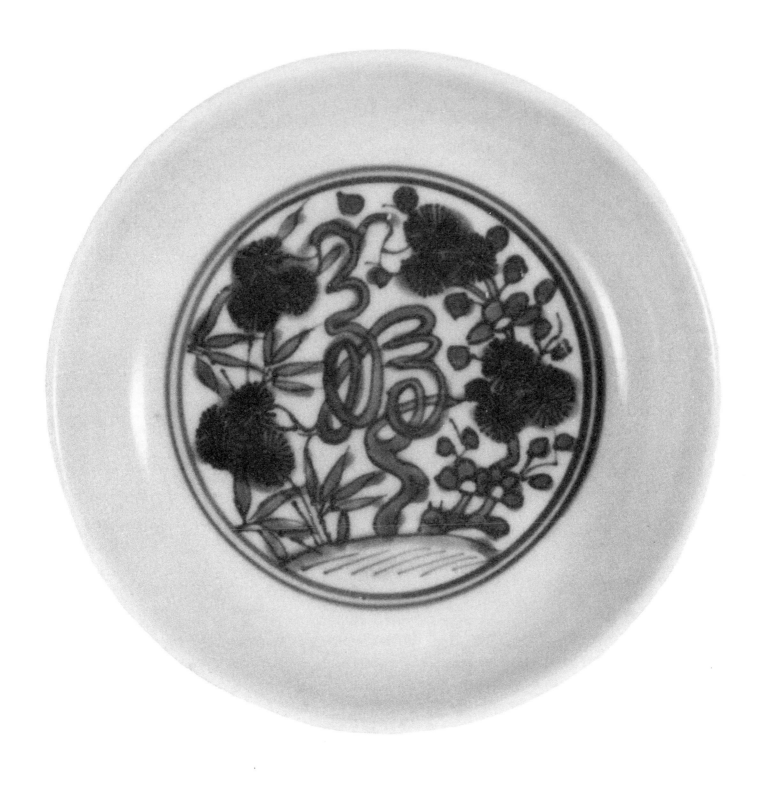

This Ming Dynasty saucer from the second half of the 16th century AD is porcelain with underglaze blue. The Chinese emperor, Chia-chang (AD 1522 – 1566) was devoted to searching for immortality and consequently had a passion for Taoist alchemy. This saucer, decorated with a tree twisted into the shape of a Chinese character, was one of many made during his reign which featured motifs such as deer, cranes and pine-trees, all auspicious long-life motifs.

# 6

# Inscriptions on Paintings

Many Chinese paintings contain a piece of calligraphy as an integral part of the composition. The poetry or prose is an essential component vital to the overall concept of an artist's design.

There are two classes of calligraphic inscriptions which appear on painting compositions as diverse as landscapes, flowers, fish and fruit. The first class is that written personally by the artist. It may be a poem, evoking, in words, the story or mood already told by the brush, with the calligraphy harmonising in style with the strokes of the painting. Alternatively, the artist's inscription may be an explanatory piece of prose adding deeper meaning to the painted subject. It is often not possible for the artist to convey the story behind the picture, or the reasoned inspiration which provoked it, without resort to words. The circumstances under which the painting was produced are often seen as important by the painter, since they help to make the painting less enigmatic. Quite often painted in humble surroundings, or after drinking too much wine, the poetry or prose integral to the painting gives insight into the painter's mind.

Of course, the inscription could also be a straightforward dedication by the painter to the patron or friend for whom the picture was intended, together with a description of the circumstances in which the painting was conceived.

Finally, the variety of meanings inherent in the Chinese language allow inscriptions to be included in a painting, which can be read either as a straightforward comment or as a veiled political allusion.

The second class of inscription is that of calligraphy written on to the paintings by people other than the artist. These people may be friends of the painter, collectors or connoisseurs. If the calligraphy is written by friends of the painter, possibly immediately after watching the painting being completed, then the calligraphy will be conceived as part of, though not integral

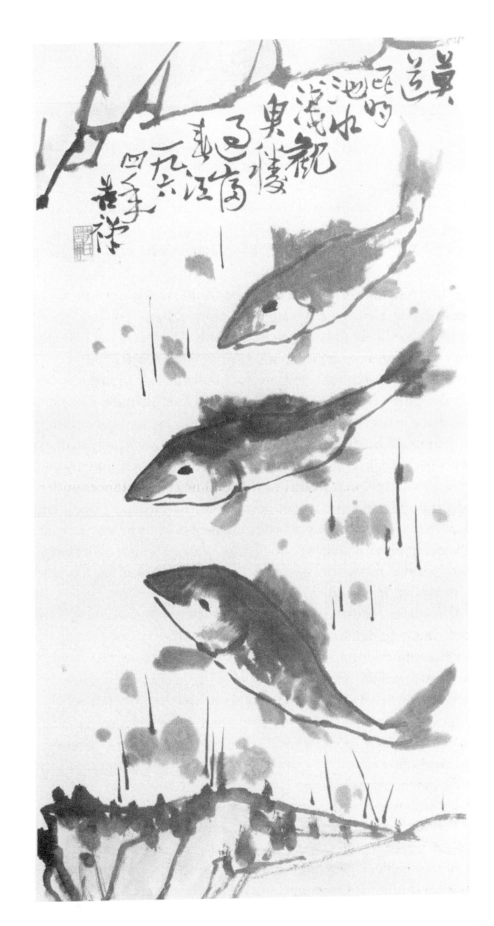

A scroll, 99.1 centimetres (39 inches) long and 49.5 centimetres (19½ inches) wide, featuring a contemporary painting by Li K'u-chan entitled 'Fishes'.

to, the picture, but other writing is often added with scant regard for the concepts of space and composition as envisaged by the artist. There are examples of calligraphy being added to 200-year-old paintings, a concept incredibly difficult for a Western art aficionado to understand.

The harmony of brush stroke resulting when an artist's own inscription is included in the painting is usually not evident when the calligraphy is added by another.

Criticism or approval from other painters, probably even the Emperor, may be added over the years, providing a source of historical and social information for later art historians. These additions also serve to authenticate paintings of a culture, where the traditional acceptance of copying from the Masters often makes it difficult to be certain of a painting's provenance.

Commentaries may be added by other artists, noting the styles and techniques of the brush work, or making comparisons between one artist and another. Great detail is sometimes given, on composition, the artist's style or an area of painting theory. If the artist himself has inscribed on his painting, for instance, a comment on how long it took him to master a particular stroke, or why he chose this particular subject to paint, then it 'opens the door', so to speak, for others to make their own comments or observations on these.

When an artist shows his paintings to his friends, who may be artists or poets themselves, they may find hidden meanings or deep significance contained within the picture which the creator himself had not appreciated.

As these poems or comments are added one by one, the picture becomes a document of profound philosophical value.

Many famous paintings have had their compositional space filled with calligraphy, some valuable, some not. It does not necessarily follow, because a great deal has been written on a painting, that the picture was, therefore, a work of genius. The Emperor Chien Lung, a great patron of the arts, wrote profusely on paintings. Often the poems were bad and the calligraphic style poor, so that the paintings themselves were spoilt.

Friends and acquaintances would sometimes write long anecdotes associated with the artist, or details about his life, his friends or his personal characteristics.

Those calligraphers with more sensibility would write their longer comments separately and then, perhaps, mount both

瓊朗夫人繪

丁未年

Calligraphy — actual size.

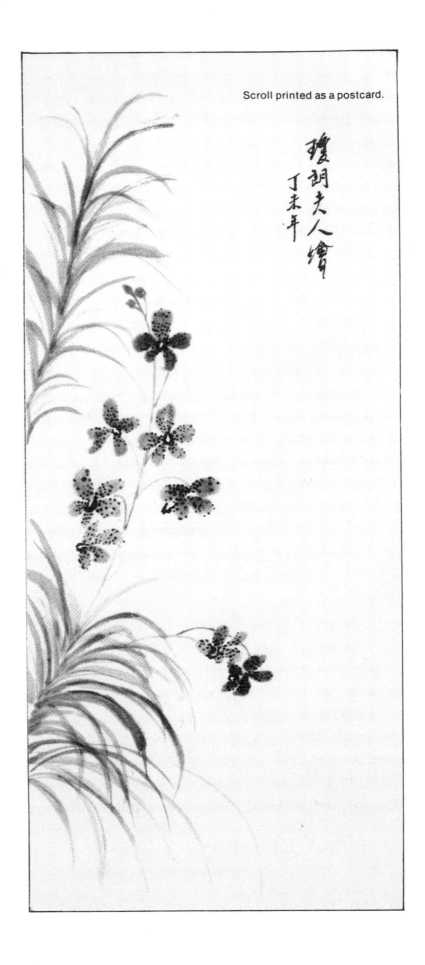

Scroll printed as a postcard.

瓊朗夫人繪
丁未年

*Orchid painting by the author,*
*with calligraphy by Sunyee.*

picture and writing together. This occurred most frequently on hand scrolls, where the format of the painting allowed pieces to be added, either at the beginning or the end of the work. These were called *colophons*.

Unscrupulous dealers sometimes added, as a colophon, false inscriptions to glorify the work, thereby making the task of viewing and appreciating Chinese works of art very difficult for later art historians and connoisseurs.

Although many Chinese paintings do contain inscriptions, it would be wrong to believe that the amount of calligraphy is proportionate to the artistic value of the work. Some artists, recognising that their writing technique or poetical composition is not on a par with their painting abilities, refrain from including calligraphy in their work.

*Shu-fa*, meaning 'Models for writing', are very important to the Chinese who have a great veneration for tradition. Works of the great masters were used as copying models for artists learning to develop their own style. Many years might be spent on copywork, the spin-offs being the production of examples of famous works being made available to more people.

New variations on old themes were also appreciated, although too much deviation from the traditional would not be so highly regarded. Calligraphic style was not only historical, but was also very much dependent upon each individual's artistic personality.

Not many old paintings survive since it has never been the custom in China to cover them with glass or protect them in any way. They were prone to the ravages of insects and, indeed, many were lost in fires or damaged in the course of everyday living.

From early times it became customary to record important announcements as well as calligraphy and painting in a more permanent manner, by carving them in stone. These copies were faithful in every detail, the fine workmanship of the carvings even recording the marks left on the paper by the brush hairs. Incised in stone, old paintings and their inscriptions could still be treasured and appreciated.

From the stone carvings, many copies could be made using the 'ink-squeeze' or 'rubbing' technique. By the Sung period these rubbings had become very popular as works to be treasured in their own right.

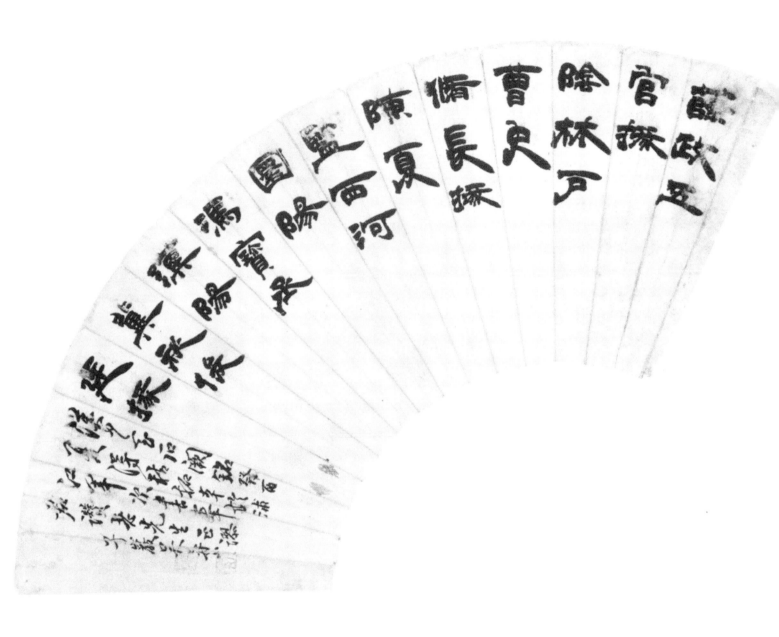

*A Chinese fan painting, diameter 52.9 centimetres (20 ⁴/₅ inches). The fan was a popular format for calligraphy, often containing two types of writing, as does this one. Sometimes the fan would be two-sided, perhaps with a landscape painting on the reverse. Although fans were much used by the Chinese, valuable fan paintings would be mounted in the form of a picture to prevent damage.*

## Rubbings

The technique for achieving this was to wet the paper with agar-agar (starch), place it on the incised surface and then tap it with a soft mallet until it had not only stuck on to the surface of the stone, but had also worked its way into the cut recesses. The paper was then rubbed with an inked pad, leaving the parts clinging to the incised stone white, while the rest of the surrounding paper was black. Considerable skill was required for this, but often the quality of the rubbing depended upon the standard of carving and the condition of the stone itself, which became worn down by repeated rubbings.

Important stone engravings, when worn down, would be copied by another stone-cutter, obviously with slight variations, so that, as with most ancient Chinese art, the originality of stone-rubbings can often be called into question.

On page 17, for instance, is an example of a rubbing which was made from a Sung Dynasty (AD 960-1127) copy. The copy is of a 10th-century BC Stone-drum inscription.

Two calligraphy rubbings from modern brass ink pots are shown opposite.

Other rubbings are shown on pages 15, 23, 24 and 26 and demonstrate the importance of this method of recording and reproducing ancient calligraphic works.

Work hard
to make
progress.

Learning
is endless.

*Rubbings from modern brass
ink pots.*

*Chinese painting equipment.*

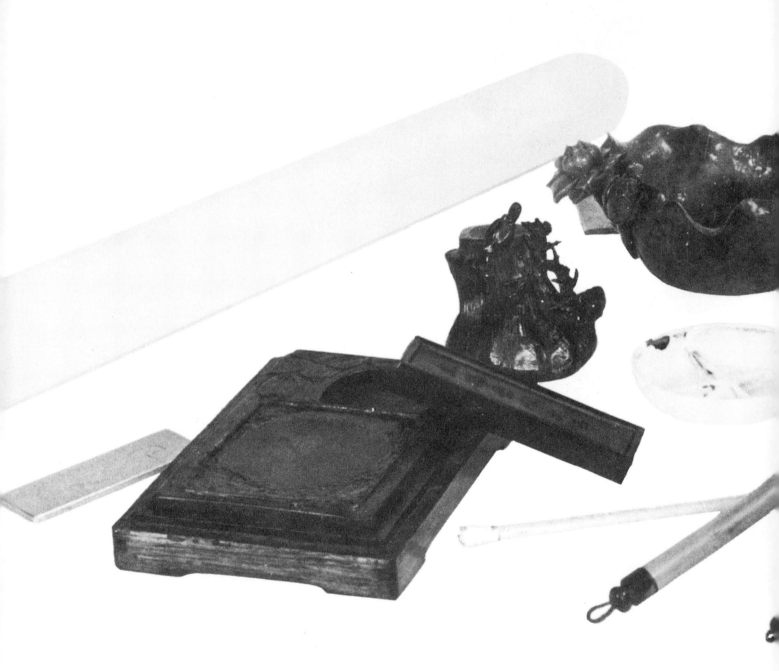

# ⑦
# Chinese Painting Equipment and How to Use it

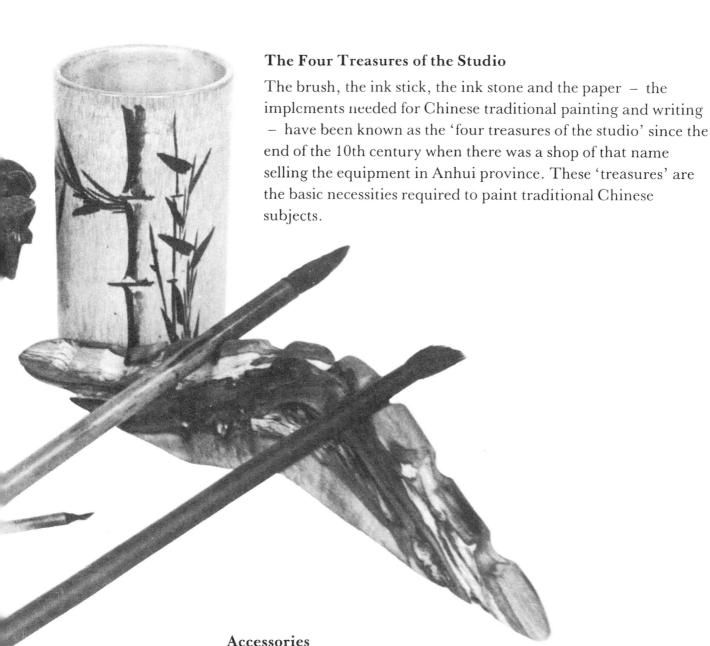

### The Four Treasures of the Studio

The brush, the ink stick, the ink stone and the paper – the implements needed for Chinese traditional painting and writing – have been known as the 'four treasures of the studio' since the end of the 10th century when there was a shop of that name selling the equipment in Anhui province. These 'treasures' are the basic necessities required to paint traditional Chinese subjects.

### Accessories

In addition to brush, paper, ink stone and ink stick, the painter needs a water holder, a plate or porcelain dish for mixing the black ink with water, and newspaper or material to serve as the absorbent backing for the Chinese paper. Weights are also needed to hold the paper in position, There are also three special

items included here: a wooden 'mountain' brush-rest, an antique water-dropper in the shape of a bird on a tree trunk, and a lotus leaf brush-washer. (Those shown are from the collection of P. Cherrett.)

## Chinese Painting Brushes

All derive from the writing brush, but early writing was done with a whittled, sharpened willow stick on strips of bamboo. General Meng Tian who lived in the Ch'in Dynasty (221 – 206 BC) is credited with the invention of the brush of hair. In the story relating to this, it is said that as he was supervising the construction of the Great Wall he saw a tuft of goat's hair stuck to one of the stones, noticed its resemblance to the willow stick and tried to write with it. The brush most used at present is a blend of the hairs of the weasel and the hare, but rabbit-hair brushes, goat-hair brushes, or even those made with panda hair or mouse whiskers are still available.

Brushes are generally classified into two main categories; *Chian* (hard hair) and *Juo Hao* (soft hair). The hard hair, such as weasel,

*An assortment of brushes.*

has more elasticity, while goat is softer and therefore has less elasticity. For a firm line, the stronger-haired brush is appropriate, but many artists still prefer the softer-haired brush, such as the one made of goat hair, because, although more difficult to control, it offers greater variation of stroke. Softer-haired brushes are also usually less expensive and can produce accidental brushwork effects which add more interest to the quality of the lines.

Much care is needed in the making of a brush. For instance, a brush of rabbit hair requires hair which is neither too soft nor too thick and, therefore, has to be obtained in the autumn when all the correct conditions are satisfied. The Chinese believe that every painter should possess his own brushes which, after training, take on his own personality and character. Although Chinese brushes are numbered, there is not always total consistency amongst the different makers. The centre brush in the illustration is a medium-sized one. The bristles are approximately 2.5 centimetres (1 inch) in length. The cost of brushes varies according to both the size and the type of hair used in the brush.

The Chinese brush always returns to a fine point when it is wet, but its uniqueness lies in its versatility. If the painter wishes, the brush can produce strokes of varying degrees of broadness, or even split itself into two or more points to produce multiple lines with a single stroke. It is usual in ink painting to use only one brush throughout, as the brush will be capable of painting everything from the finest line to broad areas of wash. It is also extremely helpful in maintaining the unity of brushwork style in the painting to use only one brush.

The most commonly used brushes are *Ta-Kai Pi*, used for writing large characters, and *Hsiao-Kai Pi*, the smaller ones used for letters. There are also especially large brushes used for large sign-writing and extra small ones for fine writing.

In the illustration overleaf, some brushes are hanging from a special rack (only to be used when the brushes are completely dry); a multiple brush, made up of ten small brushes glued together and used for washes, is lying on a polished wooden brush-rest; a bamboo 'fountain brush' with its cap at its side is available for calligraphy; a set of six matching brushes demonstrates the range of brush sizes available and helps show the comparison between the popular-sized brushes and the huge brush lying next to them.

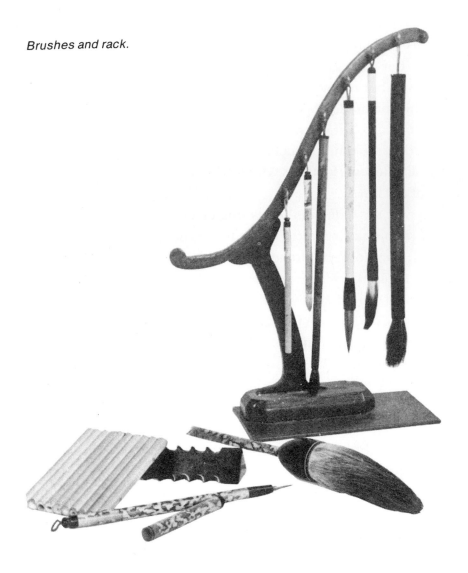

## Structure of the Brush

The Chinese brush is made up of hairs of varying lengths, bound together in a very special way and set in a bamboo holder. It is built round a central core, increasing in circumference as layers of hair are added to the core. When the correct size has been reached, the bundle of hairs is tied, glued and inserted into the open end of a bamboo handle. (Care has to be taken not to loosen the glue in these brushes, as this is their weakest point. Hot water should not be used for brush-washing. If the hairs do come out of the handle, they usually remain tied together in the bundle and can be re-inserted and glued with modern glue.) A brush from the Western world has a large amount of hair inside the handle, while the opposite is true for an Oriental brush. This special construction enables the brush to behave in a unique way when loaded with ink.

*The stages in making a brush.*

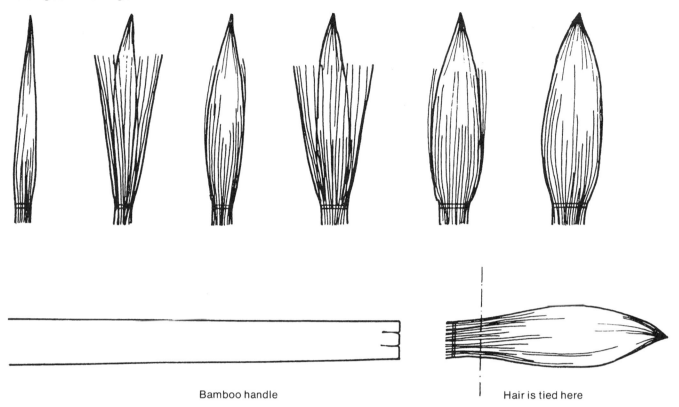

Bamboo handle

Hair is tied here

The brush-head is thoroughly dried before being inserted into the handle, first on a bed of charcoal ashes and then by suspension on weighted strings in the air. The glue used to hold the brush-head into the handle must be of exactly the right amount – too much causes the bamboo to crack, too little and the head will easily fall out. It is interesting to note that the earliest known Chinese brush, from the Warring States (around 400 BC) had a detachable brush head which was interchangeable in its holder.

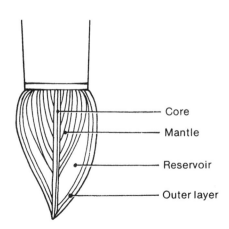

— Core

— Mantle

— Reservoir

— Outer layer

*The structure of the brush head.*

**The Structure of the Brush Head**

The *mantle* is made up of layers of shorter hair which makes the brush-head thick at the base, but does not reach the tip of the core. The *outer layers* are long enough to reach from base to tip and, as they curve round the mantle, an empty space is created which acts as a reservoir where the ink can accumulate. This *reservoir* enables several strokes to be painted before the brush has to be re-loaded.

The long central *core* is sometimes waxed to stiffen it. A stiff springy brush with a waxed core is capable of producing lines with some variation in width, while the softer, unwaxed brush creates lines of a more even width.

**Preparing the Brush for Painting**

Before actual painting can begin the Chinese brush has to be 'broken in' if it is a new one and has not been previously used.

First, the cap should be removed. This is sometimes made of bamboo, nowadays may even be of plastic. It should then be thrown away and not put back on the brush as its purpose is to protect the brush during its travels.

Next, the coating of starch, used to shape and protect the hairs, should be removed by dipping the brush in water and gently manipulating the point against the side of the paint dish, or even by very gently massaging it with the fingers.

**Looking after the Brush**

The brush should always be washed after use, taking special care to remove all traces of the black ink, which dries into a gritty state and would damage the brush if left in the hairs for a long time.

Brushes should be dried in the air by being laid down horizontally with the hairs suspended over the edge of a plate or ink stone. Traditionally, painters used a brush-rest, often made in the shape of a mountain, to rest the damp brushes while in the process of painting. For Chinese painting it is important to be extra careful with excess water or dampness as the absorbency of the paper puts it more at risk than ordinary Western watercolour painting. However, brushes should not be left to dry on the

*Brush resting on Inkstone.*

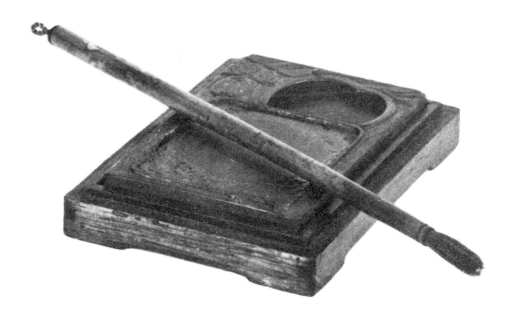

*Brush-rest.*

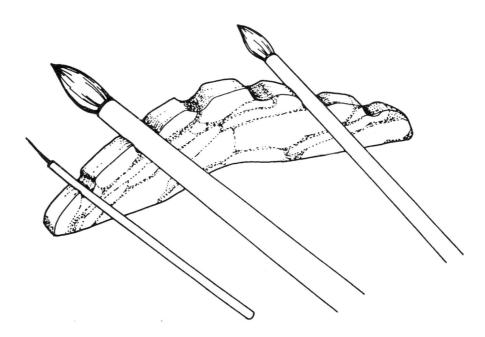

brush-rest or the moisture will seep down to collect at the base of the hairs where it may loosen the brush from the handle.

Brushes should always be kept thoroughly clean and allowed to dry naturally before being put away. Be careful of central heating or excess heat of any kind, which can be damaging to the brush handle, causing it to crack and allow the bristles to become loose.

## The Ink Stone

To make the black ink, the ink stick is rubbed in water on an ink stone. The grinding action rubs ink from the stick, enabling it to mix with the water. The finer the grain of the ink stone, the smoother the ink becomes and the longer the time needed for grinding.

The stone should be extremely smooth and hard. The most famous ink slabs are said to be from the Anhui district of China, where most are made from black stone, but there are also varieties with red or green markings forming designs in the stone.

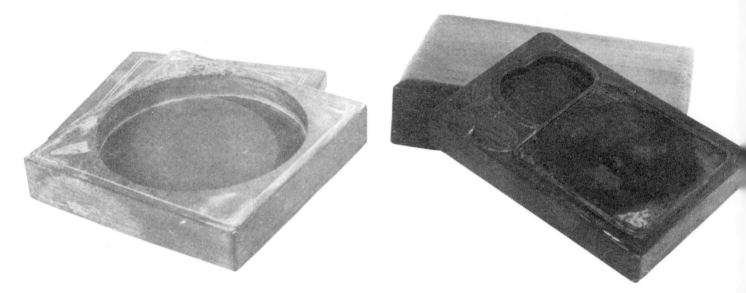

Ink stones.

## The Ink Stick

Old Chinese ink is made of pine soot mixed with glue and other ingredients to hold it together. It comes compressed into the form of a stick, sometimes round, sometimes square, decorated with characters and pictures in gold. Other ink sticks are made from lampblack mixed with varnish, pork fat and musk or camphor; these have a slightly bluish, metallic tinge to them. (Tradition says that if this ink is rubbed on the lips or tongue, it is considered a good remedy for fits and convulsions.)

A good ink stick is light in weight and very brittle. The best ink sticks produce a black which does not stick the brush hairs together or fade with time.

The size of the ink stick should be compatible with the size of the ink stone on which it is to be rubbed and sufficiently large to make an amount of ink suitable for the subject matter and painting size required. Large paintings need a large ink stick, ink

stone and brush; but a short piece of writing will not require so much ink to be made, so the stick and stone can be smaller.

The ink stick wears down very slowly with use, but the ink stone will last forever.

## Mixing the Ink

Before beginning to paint, the artist always prepares fresh ink. Although Chinese ink is available in bottles, it is not suitable for painting nor does it generate the variety of tones, from deepest black to delicate pearl grey, which can be produced by the Chinese ink stick. The action of rubbing the ink stick in the water on the ink stone has the psychologically meditative effect of preparing the mind for the painting ahead and, as such, has always been regarded almost as a sacred rite.

To mix the ink, first put some clear water into the well of the ink stone. Hold the ink stick upright and dip one end into the

*Different ink sticks.*

water to dampen it, then begin to rub it on the flat surface of the ink stone. (The amount of water depends upon how much ink you expect to need. Begin with about half a teaspoonful, then experience will help you to increase or decrease this.)

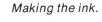

*Making the ink.*

89

Rub the ink stick strongly on the stone in clockwise circles until the ink is thick and oily. When the rubbing motion becomes difficult, moisten the end of the stick again with water or add an extra minuscule drop of water from a water-dropper or tiny spoon. The ink is ready for use when it reaches an almost oily consistency and leaves trails behind on the stone's surface. By that time the rather abrasive noise of the grinding will have become muffled and softer. As the water gradually evaporates, the mixture becomes slowly more concentrated.

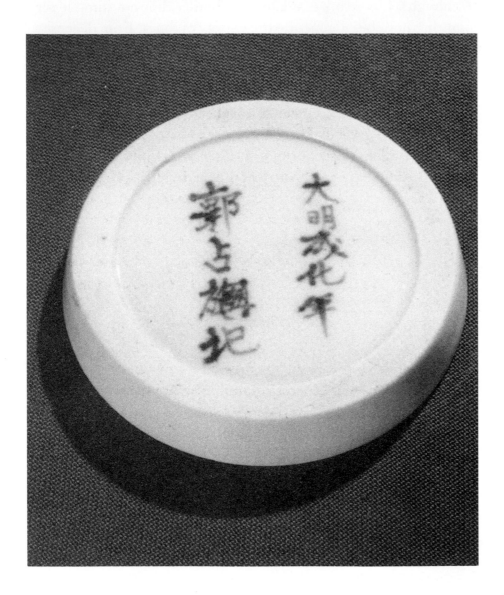

*A porcelain ink palette of the Ming Dynasty, Ch'eng-hua period (AD 1465 – 1487). Inscribed in underglaze blue, the calligraphy reads:*

*'The Ch'eng-hua period of the Great Ming; recorded by Kuo Chan-yu.'*

*Diameter 11.7 centimetres (4³/₅ inches).*

For small, simple calligraphy, it is possible to mix a quantity of ink and keep it for two or three days. Small brass ink boxes can be used for this purpose.

For letter-writing only, Chinese ink is available in bottles but this is not suitable for working on rice-paper.

### Caring for the Ink Stick and Ink Stone

The ink stick should not be left to stand on the ink stone, or it will stick to it and damage the stone, therefore allow it to dry freely in the air.

The ink stick should be carefully placed on the working table as it, too, will break if dropped. Warm water should not be used when rubbing the stick, because it will cause the ink stick to crack. When using an ink stick, keep its body straight, press it heavily and push it lightly. Don't rub in such a way that the stick becomes inclined. After use, an ink stick should be dried and then put in a cool, dark place. Excess heat, wetness or wind or exposure to the sun will cause the stick to crack. Particular care is needed in a centrally-heated atmosphere.

It is easier to rub an old ink stick than a new one, so if it is possible to keep a new ink stick for a year before use, it will save time and trouble.

The ink stone, usually solidly made of stone, will shatter or chip if dropped. Old ink, left on the ink stone at the end of a painting session, will dry into its gritty components and must not be allowed to mix with newly rubbed ink. The stone should, therefore, be thoroughly washed in clean, cold water to remove this old ink before any new ink is rubbed.

The ink stick should never be left standing on the ink stone, as the strong glue which binds the stick together will make it adhere to the stone and damage the smooth rubbing surface.

### The Painting Surface

With all the tools now assembled, the paper must be selected and then all the 'four treasures of the studio' will be ready and painting can begin.

Before the invention of paper, writing was done on fabric and

silks giving rise to the custom – still in existence – of writing maxims and sayings on large panels of silk (often red silk) and hanging them inside houses. At funerals suspended panels are carried beside the coffins of the dead, describing their characters in glowing terms.

However, the early tablet writing was easily superseded by calligraphy written on paper as the weight and volume of the tablets of bamboo or wood made the writing awkward to handle and the silk used was so costly that a cheaper substitute was most welcomed.

## Ancient Paper-making

Barks of various trees, hemp trimmings, worn linen and old nets were separately boiled into different broths and combined to form the paper. The favourite, most widely used paper was made of bamboo. Bamboo shoots were carefully selected and left to steep in a stone or brick tank whose bottom was covered with a layer of lime. Alternating layers of lime and bamboo were added until the tank was full, at which point it was topped up with water and left to ferment. After fermentation, the bamboo threads were dried and the process repeated. Finally the mixture was boiled for twenty-four hours, then simmered and eventually made into sheets which, after hardening and drying, were then made into rolls. Improvements came slowly with the discoveries of bleaching, polishing and glazing, thereby producing different types of paper.

The first papers were so fine, soft and strong that Europeans believed them to be fine silk.

Paper is now made from rice-straw, reeds and wood pulp as well as bamboo. Some papers are sized and treated with glue, others are not. Altogether there are now many types of paper with different levels of absorbency.

This absorbency is an essential quality of the paper. Individual papers – rice-paper, mulberry or bamboo – react differently to the brush strokes, so the painting surface can have a determining effect on the style of the painting. The technique of the brush stroke is affected by whether the paper surface is rough, smooth, dull or glossy, more or less absorbent, so the techniques required may include a quicker brush stroke, a drier brush than usual,

greater control of the ink, thicker brushwork and a more all-over style.

Sized paper allows for slower brushwork, as the ink does not run so quickly and is also fast drying. Therefore, fine, detailed work is easier to accomplish on this type of paper.

Practice enables the painter to find out exactly how the brush and ink react with each different paper's absorbency. Since there is still a considerable amount of individual work required in the making of Chinese papers, the same type of paper may react differently with each different batch supplied. Even the weather, be it dry or humid, can affect the reaction of ink with the paper surface.

## Using the Paper

The paper should be cut to the size required, whether from a sheet or roll, and then the remainder should be put carefully to one side, away from the danger of water or paint splashes.

Since it is so absorbent, this paper cuts better with scissors than with a knife.

Having selected the correct size of paper, it should be placed flat on newspaper, material, or blotting paper. Surplus ink from the strokes will soak through the paper to the surface underneath so it is important that this, too, should be absorbent; if it is not it will repel the liquid and cause it to run back uncontrollably into the masterpiece above it. Anyone who is worried that the print from the newspaper will mark the painting paper need have no doubts on that score, as it is oil (such as the oil in your skin) which causes the print to be removed from the newspaper; water alone will not be sufficient, so it is quite safe to use with the rice paper. One hazard which may not often occur, but is worth a warning, is that of ball-point writing on newspaper; this will cause severe marking and happens when old newspaper, possibly belonging to a crossword addict, is used.

It is essential that the painting can be moved up and down while it is being completed because the actual painting strokes have to be executed at the correct distance, so the paper has to be moved along to maintain the optimum attitude. Therefore the paper must not be fixed either on to its base or on to the working surface. One reminder at this stage is to treat the paper carefully;

the brush strokes should glide over the surface without scraping off the top layer of the paper.

In addition, the consistency of the paper requires that the paint or ink is not applied too thickly. The reason for this is that a permanent bond is effected between ink and paper which will resist running, provided that the paint has been absorbed and is not layered thickly on the paper's surface. This is particularly important in view of the method of mounting Chinese paintings.

## Paper Thickness

Painting paper does vary considerably in thickness. The levels of absorbency are not directly proportional to the thickness of each of the different kinds of paper, since the weave of the paper, whether it is open or closed, helps to affect the flow of ink through the paper. A piece of cleansing tissue is 0.076 millimetres (3/1000 inch) thick while one sheet of Chinese absorbent paper measures 0.05 millimetres (2/1000 inch) and others vary up to as much as 0.03 millimetres (12/1000 inch), this being the thick *Hosho* paper.

The most versatile paper is available in a long continuous roll, approximately 22 metres (25 yards) long. The most commonly used width is 44 centimetres (17½ inches) wide, although narrower rolls are also obtainable, some of them already divided into fixed lengths.

Usually Chinese paper has a 'smooth' and a 'rough' side which can easily be discovered by finger touch. The 'smooth' side is the correct one to use as the painting surface. The rolls of paper all have this smooth side as the *inside* surface of the roll, presumably as a way of giving it the maximum possible protection.

Various types of silk can also be used as a painting surface, but the best quality work in black is always done on paper as the essence of ink painting is the reaction between the absorbency of the paper and the brush.

## Holding the Brush

The adaptability of the Chinese brush is very much a result of the way in which it is held. The techniques are as dependent upon this as the sword stroke is to the manner of holding the sword.

The brush is not held close to the bristles, but in the middle or at the top of the handle, depending upon the stroke being executed at the time. The hand should be unsupported and be able to move freely. In ancient times the grip was not exactly the same as it is now. One book describes the moving of the ring finger and little finger from the front to the underside of the brush as being as decisive a movement as the adoption of the stirrup in warfare. A totally different method was invented which gave incredibly more control to the movement of the brush and therefore produced a whole new range of painting.

The brush is held perpendicularly between thumb and index finger, with the middle finger also touching the brush behind and below the index finger. The ring finger supports the brush from the other side and the little finger supports the ring finger. It is this combination of support from both sides that enables the artist to move the brush freely in all directions over the *flat* painting surface and still retain control over the movements of the brush.

The placing of the fingers is very similar to the method of holding chopsticks, but with a gentle touch capable of changing the pressure on the brush or the direction of movement instantly and without rearrangement of the grip.

The brush can be held vertically or obliquely, but in all cases the grip remains the same. It is not an easy position to take, especially for those who have already had experience with Western brush techniques, but it is essential to the correct handling of the brush in all its manifest and diverse facets.

*The upright brush position*, although it can only produce a line, can give a variable thickness according to the pressure which is exerted at the time of painting. If only the tip touches the paper lightly, the stroke will be a thin one; if pressure is applied, the stroke is broadened because of the extra bristles used.

In the vertical position, the hand leans backwards from the wrist almost making an angle of 90° between the arm and the hand. With the brush held in this position, a space is formed in the palm of the hand of sufficient size to hold an average egg.

*Vertical brush position.*

In the *oblique position*, the brush tip and the upper bristles move parallel to each other and their paths are separate, so that a quite different effect is obtained.

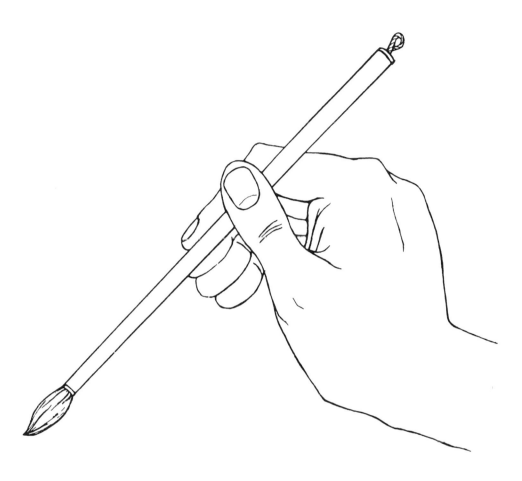

*Oblique brush position.*

The position of the fingers on the brush can be varied by moving the grip higher up the handle for large, free-flowing strokes and lower down for small delicate strokes. Many large calligraphy paintings are impressionistic in essence, so it is very important to achieve these free-flowing brush movements. If the painter is working too close to himself, or even leaning too far away while holding the brush, this will also affect the strokes as the former impedes movement and the latter causes lack of control.

## Brush Pressure

Pressure is the amount of force used by the artist when pressing the brush down on the paper. The heavier the pressure, the wider the line. This control is exceedingly difficult to master, but is essential to the correct formation of calligraphic lines in particular. The problem lies in the fact that once pressure has been placed on the brush, thus flattening the bristles, it is extremely difficult for the brush to spring back to its previous shape. Some types of hair are more resilient than others but, in general, the heavier the pressure the more difficult it is for the brush to spring back to its original position. A strong line results from a movement in which the brush continues to retain its elasticity – its springing force. To achieve this, all the elements inherent in brush control need to be observed simultaneously, that is, the correct amount of dampness, speed and direction. A brush should not be 'punished' by excessive pressure as the strength of the line will disappear if its 'elasticity' has gone.

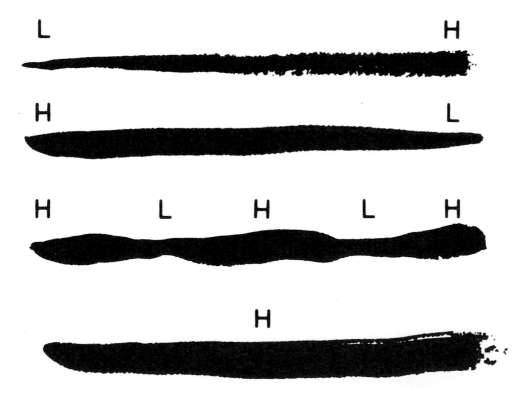

*Examples of light and heavy pressure.*

98

Effect is not only related to position and pressure, but also to the speed of the stroke. In the main, the broad stroke can be made at a slower pace than the thin stroke.

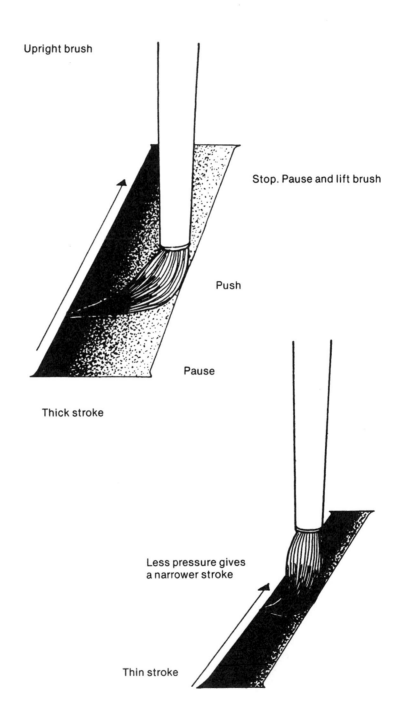

Brush positions for variable stroke thicknesses.

**Arm and Brush Movement**

In order to ensure that the brush moves freely, so that the lines are fluid, the arm must move freely in the air above the paper. Lines can then flow continuously with no demarcated points where the motion has come to a complete stop. The brush should be gripped lightly and the whole arm moved from the shoulder. This is particularly important when painting large characters. It often helps to hold the other hand flat on the paper or table, away from the working area, as this aids in maintaining the body's balance.

The essence of Chinese painting is contained within brush control. The skills involved come only with practice; with continuous involvement and increased concentration, an instinct develops which guides the brush into appropriate positions and enables the hand to apply correct pressures, thereby achieving the desired results.

**Types of Brush Stroke**
*Wet brush strokes* (brush loaded with a lot of ink). The ink runs loosely into the paper.

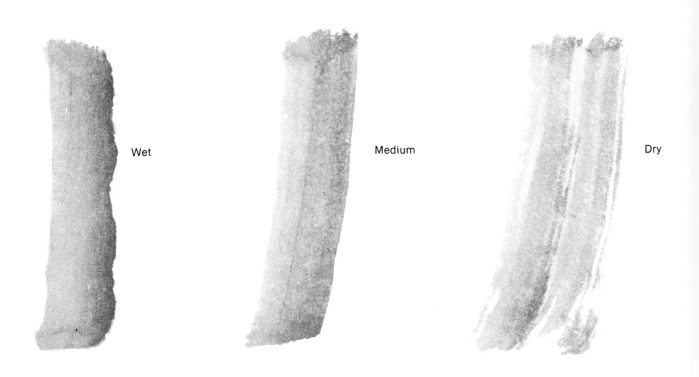

Wet        Medium        Dry

*The three brush strokes.*

*Medium brush stroke.* The edge of the stroke is clear and clean.
*Dry brush stroke* (very little ink on the brush). The brush skims the paper, thereby allowing the brush to miss the paper in some places. This is sometimes called 'flying white'. Great care should be taken not to use this technique excessively.

A common difficulty occurs when changing from a wet brush stroke to a dry one. Following a series of large wet strokes, it is best to remove all surplus liquid by blotting on tissue or squeezing the bristles gently before loading again for the dry stroke. Remember always to maintain the brush point; some Chinese painters lick their brushes continuously to keep them in shape.

As with all the techniques of this traditional art form, only practice will enable the painter to judge whether the brush is loaded correctly. It is as well to remember also that all stroke-painting errors need not necessarily be due to incorrect brush loading, as many other factors can be involved.

## Loading the Brush

The capacity of the Chinese brush to hold water and ink is one of its most important features. Strokes can only be executed correctly and with control if the brush has been correctly loaded. The amount of water in the brush controls the wetness of the stroke. If the intention is to paint a brush stroke which flows freely over the surface of the paper, but is still within the painter's control, then it is not only important for the brush not to be too wet (which can cause over-absorbency in the paper), but also for it not to be too dry (which stops the brush flow and causes spaces to appear in the brush stroke).

Water serves as a lubricant for the hairs in the brush, so that every hair can move freely. Should the brush be too dry, then the hairs will be too crowded and will generate friction when the brush head is moved, resulting in the brush splitting and producing a poor quality line. There may, however, be occasions when this effect is deliberately planned to give interesting texture to a large character, in which case it is then permissible to restrict the moisture contained within the brush-head.

For small-character calligraphy, only the brush tip needs to be loaded, but for large characters, where the strokes will have considerable variation in thickness, a large brush, fully loaded, will be required.

Correct brush-loading requires time and patience. If it is rushed, then this fact will immediately be evident from the brush strokes, so it is important always to be careful to load correctly.

First make sure that enough ink has been made and transferred from the ink stone, either to a fairly shallow bowl or to a plate with an edge. These should be large enough to accommodate all the brush hairs if the calligraphy size requires the bristles to be fully soaked. Then, roll the brush between the fingers so that the brush point is maintained at all times. Gently scrape the outside surplus off the brush by stroking the bristles against the plate edge. This also serves to push the liquid into the centre of the bristles. Repeat this soaking and stroking procedure several times until the brush contains the amount of ink necessary to achieve the desired brush strokes.

*Brush being scraped on the side of the palette.*

This famille verte *brush-pot of the K'ang-hsi period (AD 1662 — 1722) of the Ch'ing Dynasty is decorated with a scene showing people reading. A collection of small books sits on the ground nearby, while a calligraphic fan cools the readers while they sip tea.*

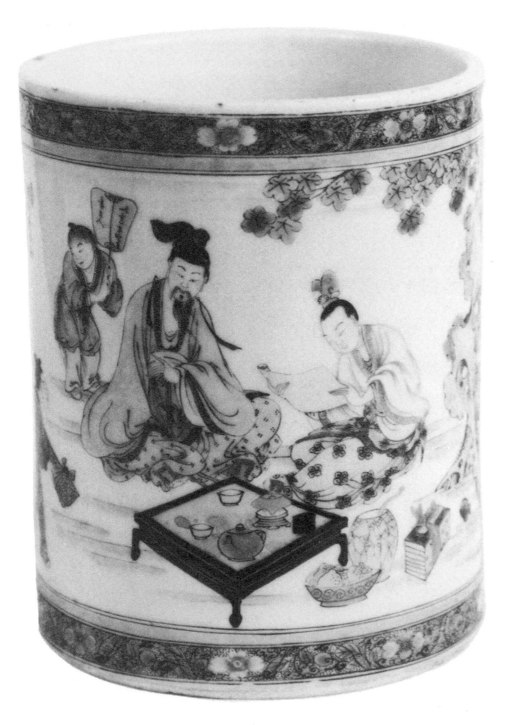

This is a circular ink palette of the Ch'ing, K'ang-hsi period (AD 1671). Diameter 19.5 centimetres (7⁷/₁₀ inches). The sides and borders are decorated with sprays of prunus and chrysanthemum and the panel has a dated inscription in archaic characters:

'Returning home with a stone from the river,
I carry an ocean tucked in my sleeve.
It is given to you to make an ink stone,
That will endure a thousand years;
Transformed in the potter's kiln,
It is made round and magical as the bright moon,
When in ink you record something good,
What you achieve is doubled in value,
Your words will be linked up into a unity
And achieve a greatness all their own.'

Inscribed by I-an Chun-chih in the autumn of the Hsin-hai year (AD 1670).

*Two versions of the character 'Long' by the author's student Mei-Ling.*

106

# 8

# The Techniques
# of Chinese Calligraphy

The term calligraphy derives from the Greek word *kalligraphia* which means 'beautiful writing'.

The Chinese have such a love of the written word that they are taught from early childhood never to tear up paper which has writing on it. There are still small pagodas specially built for the burning of waste paper which bears writing. Characters are so highly respected that they are not thrown carelessly away but taken to the 'Pagoda of Compassionating the Characters' for ritual destruction.

Shop signs, banners, advertising boards, the Chinese are surrounded by beautiful writing in spite of the advent of the typewriter and printing.

From the 3000 small seal characters of the Ch'in Dynasty, the number increased by AD 200 to over 10 000 and has now reached over half a million (although for basic reading and writing the number required is only approximately 4000).

While increasing in number, characters changed considerably in form. The changes came about for various reasons – the need to write more quickly, the improvement in writing materials and also because of a wish to write characters more pleasingly artistic to the eye.

The development of these different forms of written characters are shown here from the bone carving of the Shang Dynasty to the standard form of modern Chinese writing.

Within the period AD 588 to the present day, there have developed three types of writing which are used appropriately to their context:

*Symbols for 'moon' in three styles.*

Running          Standard          Grass

| Bone carving<br>Shang Dynasty<br>1700 – 1000 BC<br>Also found on<br>shells | Large seal<br>Chou Dynasty<br>1000 – 226 BC<br>Inscribed on<br>bronze and stone | Small seal<br>Ch'in Dynasty<br>226 – 206 BC<br>Still used today<br>on seals | Clerical style<br>Han Dynasty<br>206 BC – AD 580<br>Formalised<br>official script | Standard<br>Sui Dynasty<br>AD 580 – present |

Three hills or rocks                              *Shan*            Mountain

The branches, trunk and roots              *Mu*              Tree

First, head and arms, later, legs only      *Jen*            Man

Stream with eddies on either side            *Shai*            Water

A picture of the sun                              *Jih*              Sun, day

108

Head, scales and tail                                    *Yu*            Fish

Fingers and lines of the hand                            *Shon*          Hand

### The Stages in Painting a Character

1. Loading the brush.
2. Holding the brush. Always begin with the brush held vertically with a grip which is firm but not painful to the fingers.

   The average brush length is about 6 *t'sun* (a *t'sun* is 3.3 centimetres or 1³/₁₀ inches). Grasping the brush in different positions along its length affects the type of calligraphy produced:

*K'ai-Shu* (regular style) – grasp the brush 1 *t'sun* from the tip.
*Hsing-Shu* (running style) – grasp the brush 2 *t'sun* from the tip.
*Ts'ao-Shu* (grass style) – grasp the brush 3 *t'sun* from the tip.

Held too near the tip, the strokes will appear heavy, while if the hand position is too high, the strokes will be weak. A very tight hold produces severe, strong strokes, while a looser one will result in graceful, more fluid characters.

3. Constructing the individual strokes which make up the characters. The Chinese characters, the written symbols of the Chinese language, are usually made up of several parts. Each part of the character is called a 'component'. (Some 'components' are characters in their own right.) Each component is composed of a number of basic strokes and the following are the seven most elementary ones.

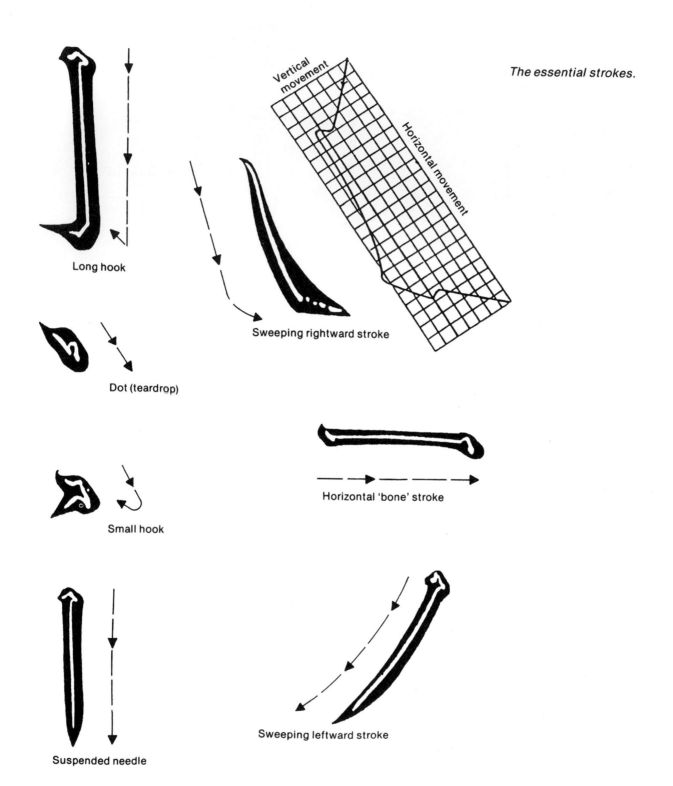

*The essential strokes.*

Long hook

Sweeping rightward stroke

Dot (teardrop)

Horizontal 'bone' stroke

Small hook

Suspended needle

Sweeping leftward stroke

The solid white line in the centre of the stroke shows the path of the brush's centre point, while the dotted-line arrow indicates the path the brush takes to make the stroke.

4. The structure of the stroke not only involves both horizontal and vertical brush movements, but also a variation in pressures. The diagram shows how these are achieved.

Firstly for the horizontal 'bone' stroke:

At the horizontal surface of the paper, the brush tip moves along this path:

To achieve the rounded start and finish to the stroke, the arrowed line shown is not straight because the brush must begin and end with a folding-back movement.

In addition, the brush tip moves vertically along the horizontal path, pushing into the paper with different pressures, shown in the diagram as variable depths below the paper surface.

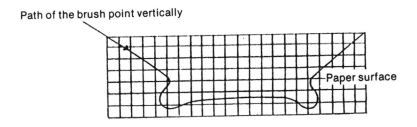

It is as though the brush comes vertically down on to the paper, penetrating strongly at first, then more lightly, the stroke being completed with a final heavy pressure and flick.

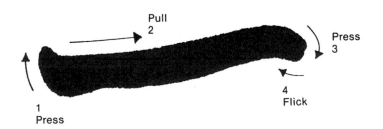

The vertical straight stroke is made with the brush tip following the path shown. Again, the rounded start is achieved by the folding-back movement of the brush as the stroke begins. No brush movement is needed at the end as the base of the stroke comes to a point.

The pressure required as brush meets paper is similar to that used during the 'bone' stroke at the start but, of course, the brush comes smoothly off the paper at the end of the stroke.

In every kind of stroke there are three main brush movements. *Tun* – 'To crouch', *T'i* – 'To raise' and *Na* – 'To press the hand down heavily'. When the brush is filled with ink, it is still true that not all the hairs touch the paper. The amount of the brush hair which does touch the paper during a stroke is 70% for *Tun*, 50% for *T'i* and 90% for *Na*. This is why *T'i* will make a thin section of the stroke and *Na*, a thick section. *Tun* is always used for starting and ending a stroke, and also for turning or joining two strokes. *T'i* starts with half the brush on the working surface and is gradually lifted, ending with the point only touching.

Vertical movement

Horizontal movement

Paper surface

Tun – – T'i
Na – – T'i

1. *Tse*    The dot
2. *Le*    Horizontal
3. *Nu*    Vertical
4. *Yo*    Hook
5. *Ts'e*    Uptilted
6. *Liao*    Declining
7. *Cho*    Pecking
8. *Chieh*    Trailing

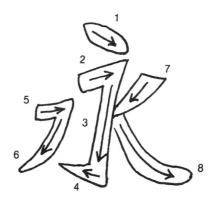

The character *Yung*, meaning 'Eternity', provides a good opportunity to practise putting together the basic strokes.
5. Each stroke must be considered in relation to the others in the character as a whole.

Using, as a basis, the same character *Yung*, the strokes would, in fact, be painted not individually but in combinations, the order being as shown in the diagram by the small numbers.

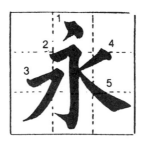

## Composition of the Characters

As the elements of a character are generally put together in groups of two or four, it would seem that the square format would most appropriately be divided into four for composition purposes. However, the nine-fold square [grid] has proved more valuable to the calligrapher as [grid] it helps in the achievement of the balanced [grid] asymmetry so necessary to the artistic value [grid] of calligraphy. The nine-fold square, which is, of course, imaginary for advanced calligraphers, but is used to form the basis for character formation for beginners, enables the writer to balance the right and left sides of a character as well as the top and bottom.

A character should have a centre of gravity which falls upon its base so that it appears stable. The parts should be spaced to avoid a sense of unbalance while developing a sense of dynamism caught in suspended animation.

The following examples demonstrate the importance of using this format to construct the Chinese characters.

(a)

(b)

*The character* Ti — *'Earth'.*

The two-element side-by-side character, when written in (a) appears separated into its components, but when written in (b) the larger size given to the right-hand component causes the two elements to lean together so that they form a more composite character.

114

Here again, increasing the size of the top element draws the character together in a more integrated way.

*The character* Tan — *'Sunrise'.*

(a)

(b)

Further practice, for instance based on the horizontal 'bone' stroke, can be tried as follows. In each of these examples, the bone stroke is the same size, but in a different position on the grid. (The stroke order is indicated by the number.)

Character practice for the vertical brush stroke.

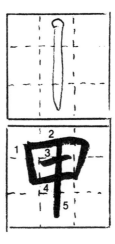

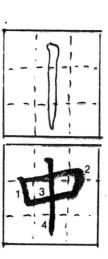

*How children learn character combinations.*

猴

Tree

樹

Monkey

Another way to practise controlling the brush before going on to more complicated characters is to use the square as a grid for more formalised movements.

These can also be tried as practice pieces in the same way.

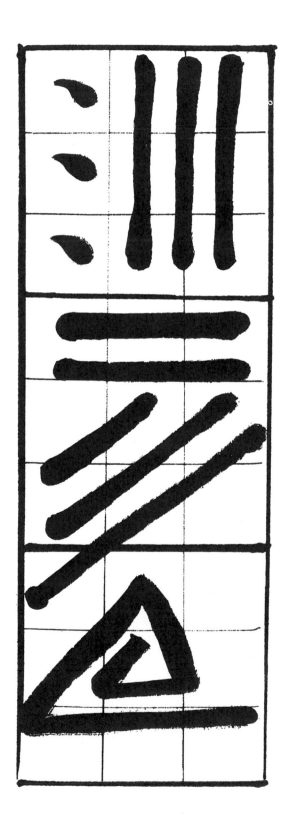

When considering the composition of a character, the first requirement is that it should appear to be standing firmly. This is no problem when a character has a vertical centre stroke, as in *Chung* – 'Middle', but can cause problems in a character with as many as twenty strokes. Multi-stroke characters, therefore, have to be carefully spaced so that they are never overcrowded, nor too spread out. *Shou* – 'Long life', is a multi-stroke character. In fact, it is usually easier to achieve a pleasing effect with a multi-stroke character than it is with a very simple one.

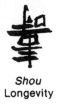

Chung
Middle

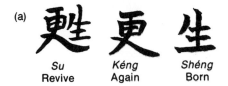

Shou
Longevity

To avoid cramping in combination characters, strokes can be elongated or shortened or even reduced and inserted, to make the final character blend together artistically. In (a) *Sheng* has been reduced to fit more closely with *Keng*.

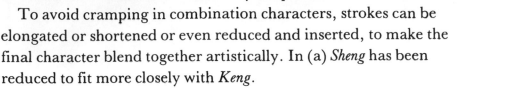

(a)

Su
Revive

Kéng
Again

Shéng
Born

In (b) *Chiu*, the character has had its 'dragon-hook' diminished to make the artistic combination effective, while (c) demonstrates the lengthening of the 'dragon-tail' to encompass the reduced-size *Jih*.

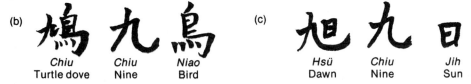

(b)

Chiu
Turtle dove

Chiu
Nine

Niao
Bird

(c)

Hsü
Dawn

Chiu
Nine

Jih
Sun

Widths, too, can be changed, to make the whole into a more beautiful pattern (d) or an element can be placed under the cover of another element of the character (e).

(d)

Féng
A lofty peak

(e)

Ming
Fate

(f)

Pao
To wrap up

One element of a character can also 'embrace' another (f). All these amendments, which cannot of course be presented in this way if printed character by character, are part of the heritage of Chinese calligraphy as an art form.

118

Beautiful characters are not achieved, however, by learning a set of rules. Ideas should be clear in the mind, even before picking up the brush. Ink should be neither too pale, nor too thick; shape and spacing, proportion and co-ordination, formed by mind, eye and hand working together, will, after much practice, result in calligraphy which has been a pleasure to produce and is a delight to view.

However many strokes are needed to produce a character, they must follow the laid-down order of painting which is described in the following chart.

| Example | Stroke order | Rules |
|---|---|---|
| 十 | 一 十 | Horizontal before vertical |
| 大 | ナ 大 | Left before right |
| 夠 | 夕 夠 | From top to bottom |
| 你 | 亻 你 | Left component before right component |
| 月 | 冂 月 | From outside to inside |
| 国 | 冂 国 国 | Inside precedes the sealing (closing) stroke |
| 小 | 亅 小 小 | Middle precedes the two sides |

119

The basic structure of each character is balanced and logical and each stroke follows the other in a precise and rhythmic order.

The individual strokes already described should be practised first, with the painter sitting in a very erect position, or standing, if the work is to be particularly large. The brush should be kept upright and, to allow for totally free movement of the arm, the wrist should not be allowed to rest on the surface of the paper. The ink used should be a rich, strong black and the brush loaded thoroughly but without being supersaturated. Remember to increase the pressure to broaden the stroke and release it to obtain a narrower line. Try to develop graceful hooking strokes, carefree but strongly formed sweeping strokes and well-proportioned but self-contained long strokes. Boldness is required for the dots and short strokes.

As with all Chinese brushwork, confidence has to be developed by practice. A bold, sure touch is a necessity for successful calligraphy. No possibility of erasing, altering or obliterating is available for the Chinese calligrapher, but constant practice using the brush will eventually develop the expertise required.

Developing from this, the quality of the brushwork is judged, not only by the length and thickness of the individual strokes, but also by how the strokes meet each other as they are written in sequence to form each character.

Most of these rules and the basic stroke elements are contained within the much-used character for 'Long life'. This character, *Shou* (pronounced 'show') is to be found as a single decorative piece of calligraphy on a scroll, as an embroidery motif, on pottery and contained within many written expressions of general goodwill on Chinese New Year cards. It can most usefully be tried as a calligraphic painting motif, after the individual strokes have been practised.

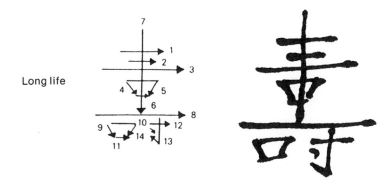

Long life

Follow the arrow directions and paint the strokes in the order as shown. It often helps to vary the size of the character to find which particular format suits you best for practice purposes.

Another popular character is 'luck', which is *Fu* (pronounced 'foo'). Again, the arrows give both direction and order of stroke, so that the character will develop rhythmically as it is painted.

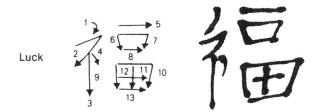

If one stroke does not quite join on to the next, it is much better to leave the slight gap than to attempt to add an extra piece to the character and, of course, as always with traditional Chinese painting, strokes cannot be successfully 'tidied up' if the brush technique has caused an incorrect stroke to be formed. No amount of description can substitute for the marvellous feeling of accomplishment when, after many faulty practice pieces, one character, or even one stroke, appears faultlessly on the absorbent painting surface.

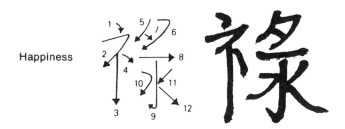

## Order of Writing More Than One Character

The general rule is to work from the top down, and from left to right within each character. The successive characters are placed in vertical rows, starting at the top of the paper and at the right-hand side. Each new row begins at the top and is placed to the left of the previous one.

Although everyday Chinese writing is now done horizontally, it is still eminently acceptable for poems, couplets or decorative writing on paintings to retain the old format of vertical lines.

The addition of the character for 'Happiness' to the two already described will enable the painter to write 'All good wishes – luck, happiness and long life'.

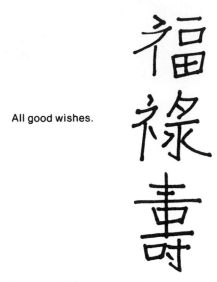

All good wishes.

Another small but useful series of characters are the set of Chinese numbers, plus the characters for month and year necessary to enable the date to be written.

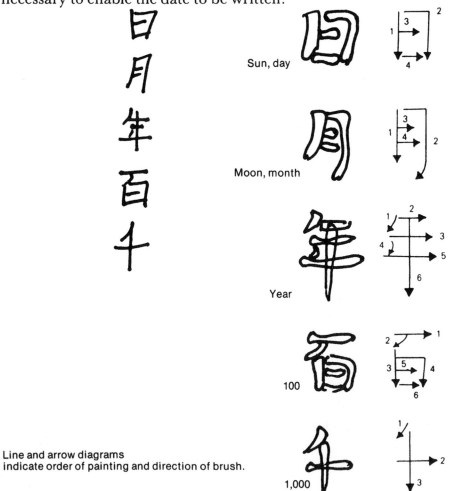

Sun, day

Moon, month

Year

100

1,000

Line and arrow diagrams
indicate order of painting and direction of brush.

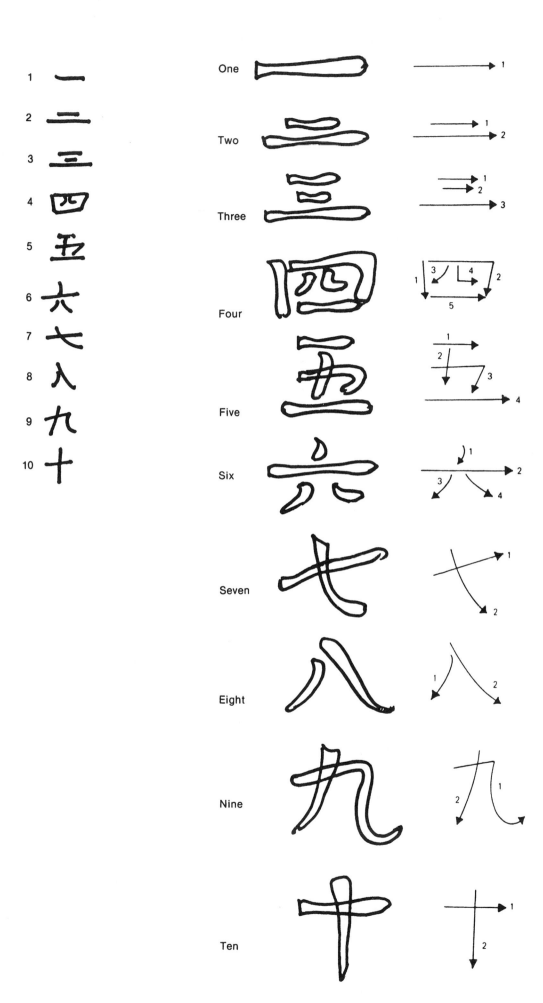

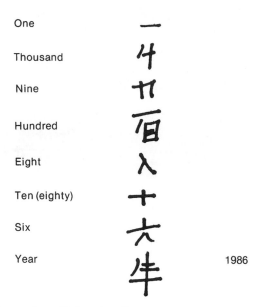

| One | |
|---|---|
| Thousand | |
| Nine | |
| Hundred | |
| Eight | |
| Ten (eighty) | |
| Six | |
| Year | 1986 |

To begin with this may be sufficient, but if more accuracy and precision is required then the month and day can be added.

| Comma | |
|---|---|
| Five (fifth) | |
| Month | |
| Comma | |
| Six (sixth) | |
| Day | |

Written characters in their pictorial form were the forerunners of today's calligraphy and also of traditional painting. They appeared on bronze vessels and probably at about the same time as embroidery motifs, with particular attention being paid to the character of the silk cocoon. Chinese embroidery pieces have examples of Chinese script worked on them, from single characters to full-length poems, producing designs rich in symbolism as well as pleasing aesthetically and intellectually. Since most ancient embroidery was made as an adornment for the robes of male officials, the longevity character – *Shou* – appeared frequently, but the most popular character on old embroidered pieces was the 'double *Hsi*' – 'Double happiness':

One 'good wish phrase', also popular on embroidery, seems to sum up the far-ranging influence of calligraphy as an art form, embodying, as it does, a wealth of ancient philosophy in a minimum of writing. The seal character inscription shown below left reads *Wu fu chin ju* – 'May you have the five blessings and embody the nine similarities (in your person)'. The 'Five blessings' are long life, wealth, health, many sons and a natural death. On the right is the modern form.

The phrase 'May the five blessings approach the door' is often written on red paper and pasted on the main entrance to a Chinese house at New Year.

The 'Nine similarities' are embodied in the following wish: 'Like high hills, like mountain masses, like top-most ridges, like huge bulks of rock, like streams, like the morn, like the sun, like the age of the southern hills and like the luxuriance of fir and cypress, so may be thy increase and descendants to come'.

The date, or a good luck symbol, or perhaps a small poem, is the easiest way to begin to attempt Chinese calligraphy. Later the calligraphy can become the whole focus and main element of the composition but, of course, it is always very difficult to write with confidence in a foreign language.

The importance of calligraphy in Chinese life cannot be underestimated. Scrolls of calligraphy are traditionally offered as gifts and they are used as wall-hangings, hand scrolls and album leaves in the same manner as paintings. The two arts share a common origin and each evolved as a means of making an aesthetic statement, expressing the underlying principles of nature.

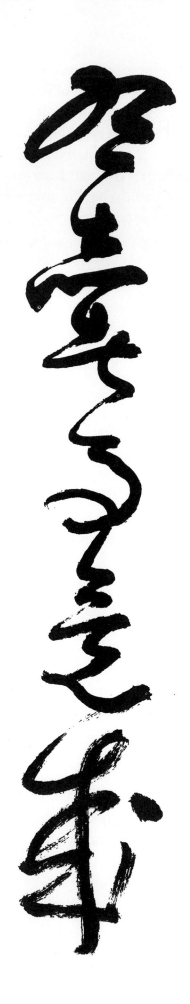

Calligraphy by
Professor Joseph Lo.

# Bibliography

*Chinese Calligraphy* Chiang Yee, Harvard University Press, 1938 and 1982

*Chinese Couplets* T.C. Lai, Swindon Book Co., 1969

*Chinese Decorated Letter Paper* T.C. Lai, Swindon Book Co., 1978

*The Chinese Eye* Chiang Yee, Indiana University Press, 1964

*The Chinese Theory of Art* Lin Yutang, Heinemann, 1967

*Fun With Chinese Characters* Federal Publications, Singapore, 1980

*Illustrated Catalogue of Underglaze Blue and Copper Red Decorated Porcelains* Margaret Medley, Percival David Foundation of Chinese Art, 1976

*In Pursuit of Antiquity* Roderick Whitfield, Charles Tuttle, 1969

*Tao Magic – the Chinese Philosophy of Time and Change* Philip Rawson and Laszlo Legeza, Thames and Hudson, 1973

*Walking to Where the River Ends* Wang Fang yu, Suzanne Graham Storer and Mary de G. White, Archon Books, 1980

*The World of Ancient China* J.B. Grosier, Tudor Publishing Co., 1972

Other books by Jean Long:

*How to Paint the Chinese Way* Blandford Press, 1979

*Chinese Ink Painting* Blandford Press, 1984

All these books are available in the UK and are printed in English.

Books and painting equipment can be obtained, by post if necessary, from: Collet's Chinese Book Shop, Great Russell St, London (opposite the British Museum).

# Index